Gareth McConnell

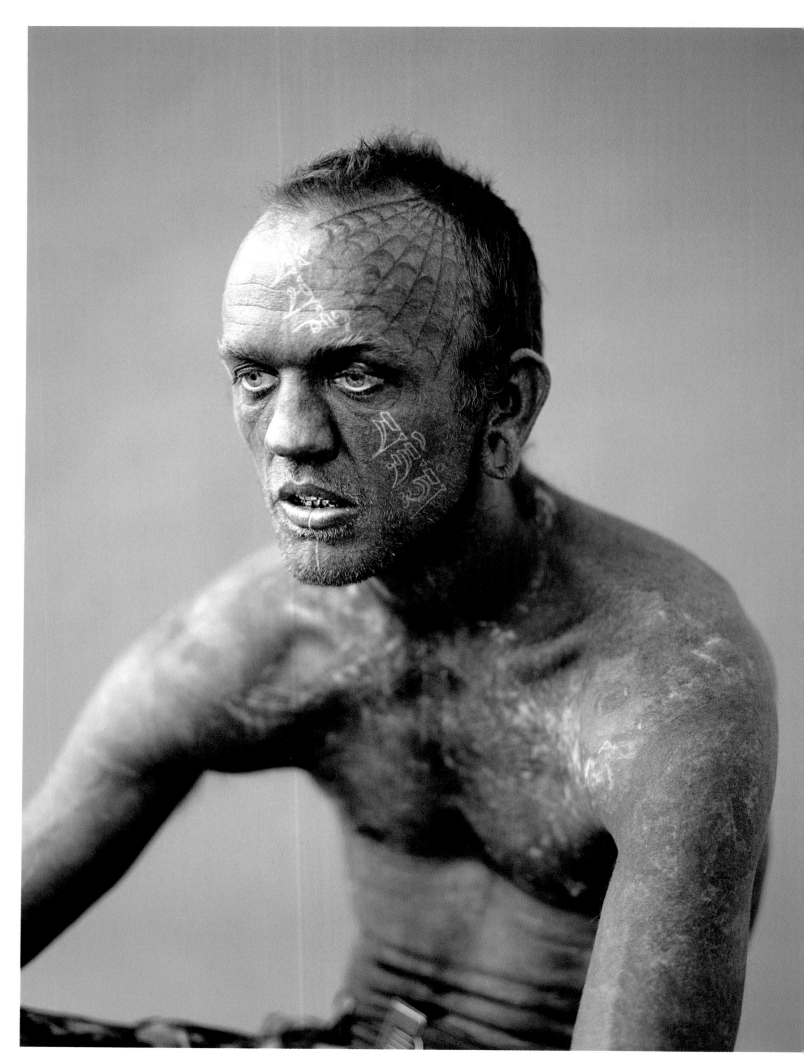

Gareth McConnell

photoworks STEIDL

Frontispiece;
Lucky Rich, the Most Tattooed Man in the World, 2003

First edition co-published in 2004 by Photoworks and Steidl.

© Photoworks/Steidl 2004
Images © Gareth McConnell 2004
www.garethmcconnell.com
Essays © the Authors 2004

British Library Cataloguing-in-Publication Data.
A catalogue record of this book is available from the British Library.

ISBN 3-88243-977-7

All rights reserved. No part of this publication may be reproduced,
stored in a retrieval system or transmitted in any form or by any means,
electrical, mechanical, or otherwise, without first seeking the permission
of the copyright owners and the publisher.

Series Editor: David Chandler
Editor: Celia Davies
Book Design: SMITH
Scans: Steidl's digital darkroom
Printing and Production: Steidl, Göttingen
Printed in Germany.

Photoworks
The Depot
100 North Road, Brighton, BN1 1YE
England
T: +44(0) 1273 607500 F: +44(0) 1273 607555
e: info@photoworksuk.org
www.photoworksuk.org

Steidl
Düstere Str. 4 / D-37073 Göttingen
Germany
T: +49 551 - 496060 F: +49 551 - 4960649
e: mail@steidl.de
www.steidl.de

photoWORKS STEiDL

Foreword

This book on Gareth McConnell's photographic work, is one of
the first publications in a new series of Photoworks monographs,
an unprecedented series of books that surveys the work of the
most important emerging photographic artists in the UK. The
series provides the first in-depth study of each artist's work,
acknowledging and celebrating their achievement to date. These
first books also represent the beginning of a new co-publishing
partnership between Steidl and Photoworks.

The book format is a prime site for the photographic image and
is a valued instrument for photographers to disseminate their work.
Generating a monograph that presents an overview of an artist's
work brings opportunities tempered with dilemmas; a balance has
to be achieved in assembling what is considered to be the artist's
most important work and gathering work that holds together
comfortably as a book. In this survey, we experience moments of
harmony, discord and sometimes abrasion; characteristic of the
subject matter in Gareth McConnell's work. Prior to this publication
only two series of his photographs had appeared in book form:
Wherever You Go, was published by Lighthouse in Poole, Dorset,
and *Back2Back* by All Change, a community organisation in
London. This monograph provides the first chance to experience
his works together and in a broader context; providing a timely
occasion to make connections and comparisons, gain a clearer, more
objective view and, importantly, to validate his accomplishment.

The experience of McConnell's work within this book is
amplified by both Neal Brown's and Simon Pooley's writing.
Their respective contributions resonate with the intense, extreme
positions we find in many of the photographs, while Charlotte
Cotton's interview with McConnell, provides an eloquent insight
into the personal experiences that drive the work. Our sincere
thanks go to each of the contributors.

This book would not have been possible without the involvement
of several individuals and organisations. Firstly, we are grateful to
Arts Council England for providing the opportunity and support
that enabled this monograph series to be published. We would also
like to thank our colleagues and co-publishers Steidl – in particular
Gerhard Steidl, Michael Mack, Julia Braun and Catherine Lutman –
for their support, invaluable advice and meticulous approach. Our
sincere thanks to Stuart Smith, for his intuitive approach to the
design of this book, and to Rebecca Drew and Gordon MacDonald,
our colleagues at Photoworks, for their help with production.
And finally, we extend our thanks and appreciation to Gareth
McConnell for the dedication and wholehearted enthusiasm he
has devoted to this project.

Celia Davies, Editor

Introduction

What's so unnerving about the body is its lack of colour. The man is alive but not alive; his pink-rimmed eyes stare out as if already trapped inside something dying. In this extraordinary figure we might sense humanity itself held in some strange and uncertain balance, literally disappearing under an illustrated screen of tattooist's ink, but also asserting itself in a defiant act of transformation and survival.

Welcome, this portrait says, to a place of extremes. And, perhaps, to a place of endurance, too, where the ongoing struggle is that between the mind and body, between severe acts of will and physical well-being.

That place and the photograph which defines it are a fitting introduction to the work of Gareth McConnell, a young Northern Irish photographer who has, over the last five years, produced a succession of powerful and emotionally charged bodies of work that have established him, at a relatively early point in his career, as one of the key figures in British contemporary photography.

Born in Carrickfergus, McConnell's life has been shaped by the violent tensions of Northern Ireland's recent history. But the 'troubles' are not, or at least not overtly, his primary subject. Despite the presence of his disarming and already celebrated work from the Albert Bar in his home town and the oblique series of details from sectarian murals, the focus of this book is more personal, bringing together an intense series of works which encompass a period, roughly 1995 to 2004, of similarly intense experience for McConnell. In fact it would be true to say that the photographs collected here mirror directly his own recent life in England and Ulster, and testify to a kind of maturity, but one of existence turned inward rather than opening out, expansive and worldly.

If one of the strongest impressions from McConnell's work is that of youth drained and wearied by experience, by drugs, by excess and by the frailties that that experience leaves in its wake, then, importantly, his work is also about strength and resilience, and the assured signature of the photographs themselves, their natural solidity and directness, is a sign of his own capacity for working through, for resolving and enduring.

This all might suggest a strongly confessional slant to McConnell's photography. And that would be partly true, but there is no direct self-scrutiny here. Rather, what stands in place of the confessional in McConnell's work is its particular sense of intimacy. Especially in his portraits, as onlookers and outsiders, we are continually brought close to his subjects, sometimes too close for comfort. Feeling a little like unwanted guests, arriving anyway after the event, we are invited into the space of a personal connection and are made aware, as Neal Brown has pointed out in his essay later in this book, that the making of the picture has involved some process of sharing. The photographer's presence is strongly felt, not as an intruder but as a confidant, a fellow traveller – someone conversant with the unspoken language. And this constitutes a form of discovery; in that speculative dialogue between photographer and subject something registers and ignites, and something of beauty is released. McConnell's *Night Flowers* series, which on first impression may be quite difficult to place in his work, is perhaps some form of metaphor for this – a simple epiphany on a journey home, one that might sustain the spirit or mark a change in thinking.

Underlying these encounters in McConnell's intimate, shared spaces is the varying status of the body, the physical self, as a measure of, or question about identity. In photograph after photograph the body is either awkwardly or casually asserted; it is proffered, abused, exposed, reclaimed and recovered. At times the body's limits are tested and then a sense of equilibrium is achieved. But journeying through McConnell's work, from the straight-backed young woman in the Albert Bar, readying herself for the camera, to the alternately energised and exhausted young veterans of the Ibiza lifestyle, we are made aware of strenuous efforts to stabilise the body, to control it and reconcile it with some other uncertain image of the self.

This idea of the destabilised body, of the self coming in and out of focus, appearing and disappearing – both as an image and as a physical presence – is reflected and painfully chronicled in Simon Pooley's text later in this book. But Pooley's story also provides another fitting context for McConnell's experience and work in its suggestion of a positive end to this cycle, a re-emerging from the point of disappearance, a final closure. Neal Brown, in his essay, also refers to McConnell's work, and his journey, in terms of a 'reconstruction' – the peace-building 'that must take place after the war'.

The last word in relation to this sense of reconstruction in McConnell's work must fall on the subject of light: that property, after all, which conditions any act of appearance or disappearance. Often made over long exposures, McConnell's photographs emphasise stillness, composure and the slow time of reflective duration. And the light that spreads a muted chiaroscuro across these pictures is a redemptive light, softening space, bringing shape and substance to McConnell's bodies and giving grace to their claims on identity.

David Chandler, Director, Photoworks

Antisocial Behaviour Part I and II

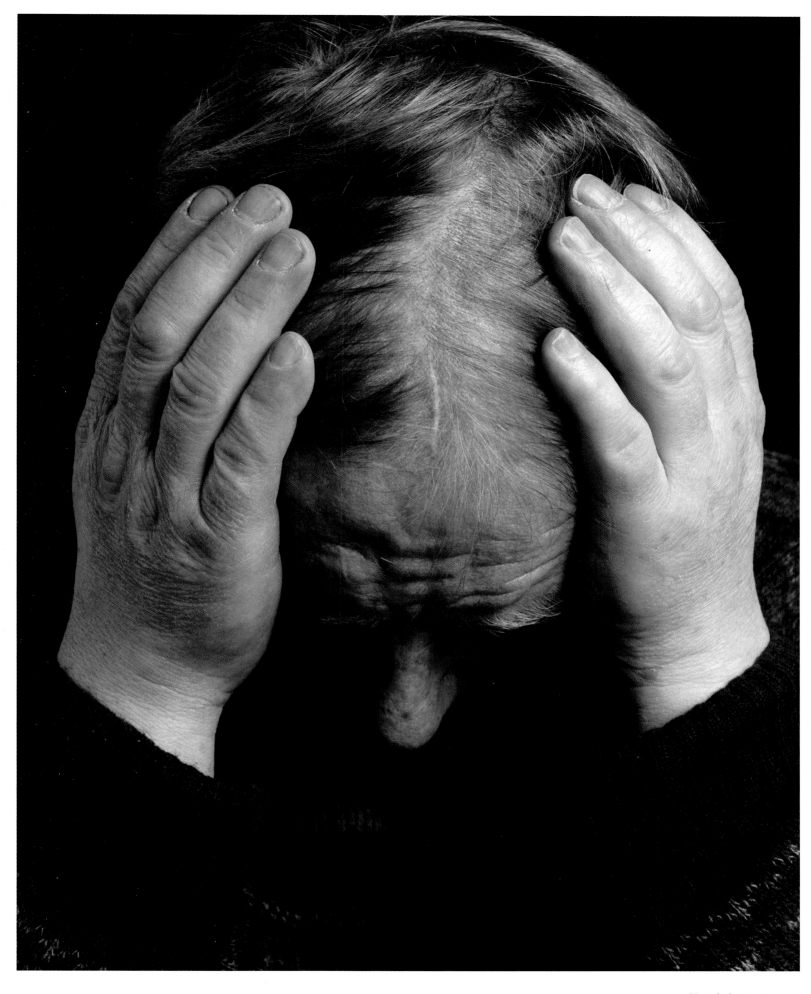

Untitled, 1995

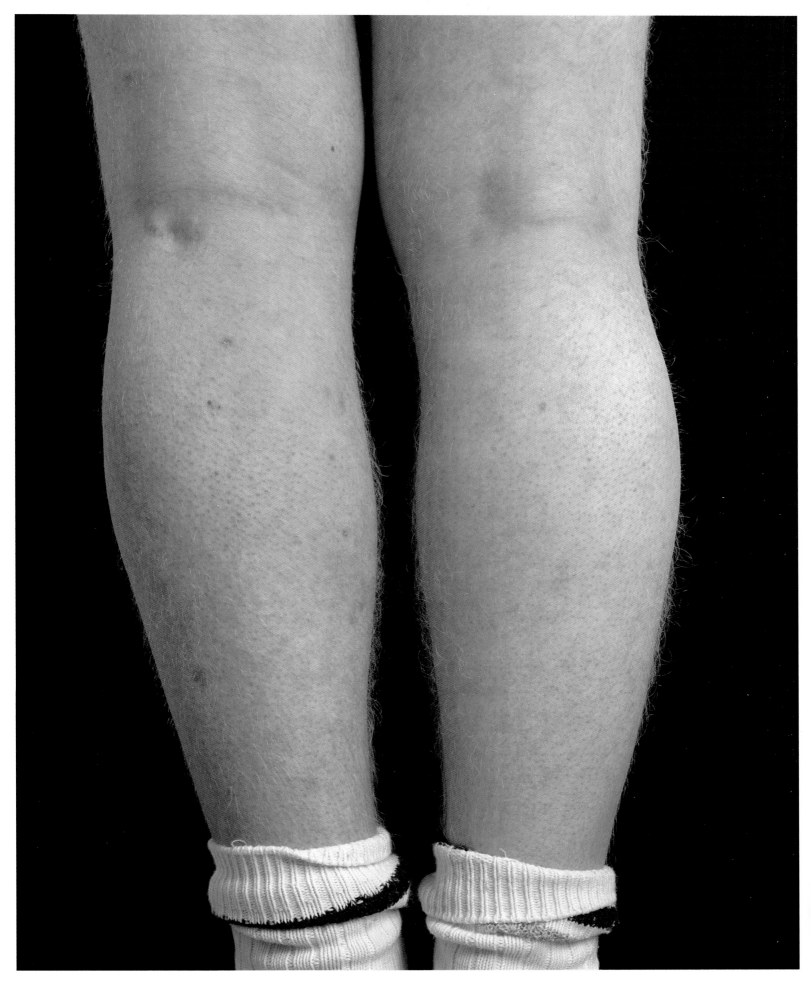

Untitled, 1995

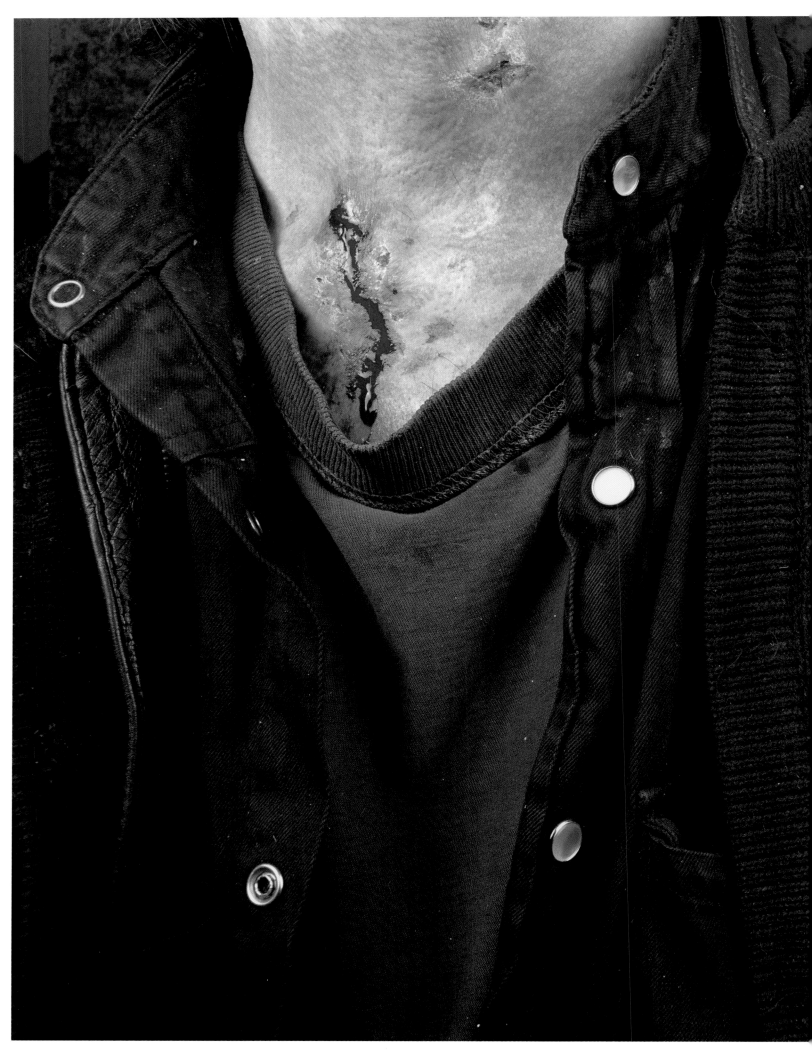

Untitled, 1995

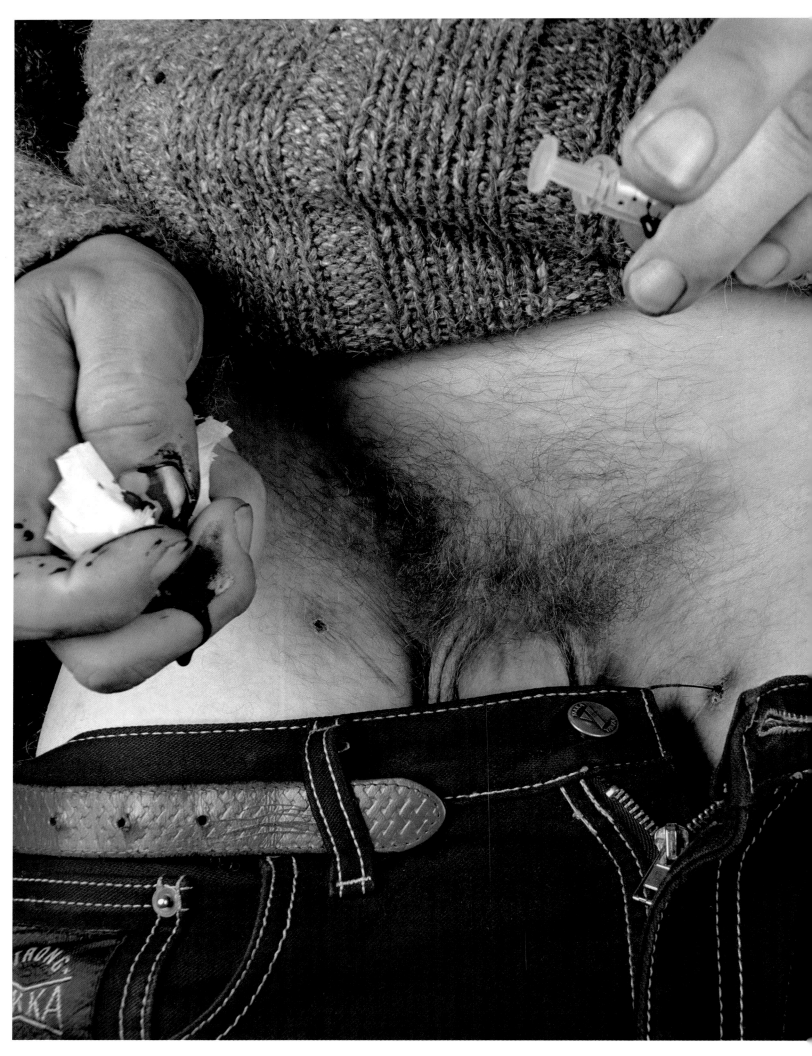

Untitled, 1995

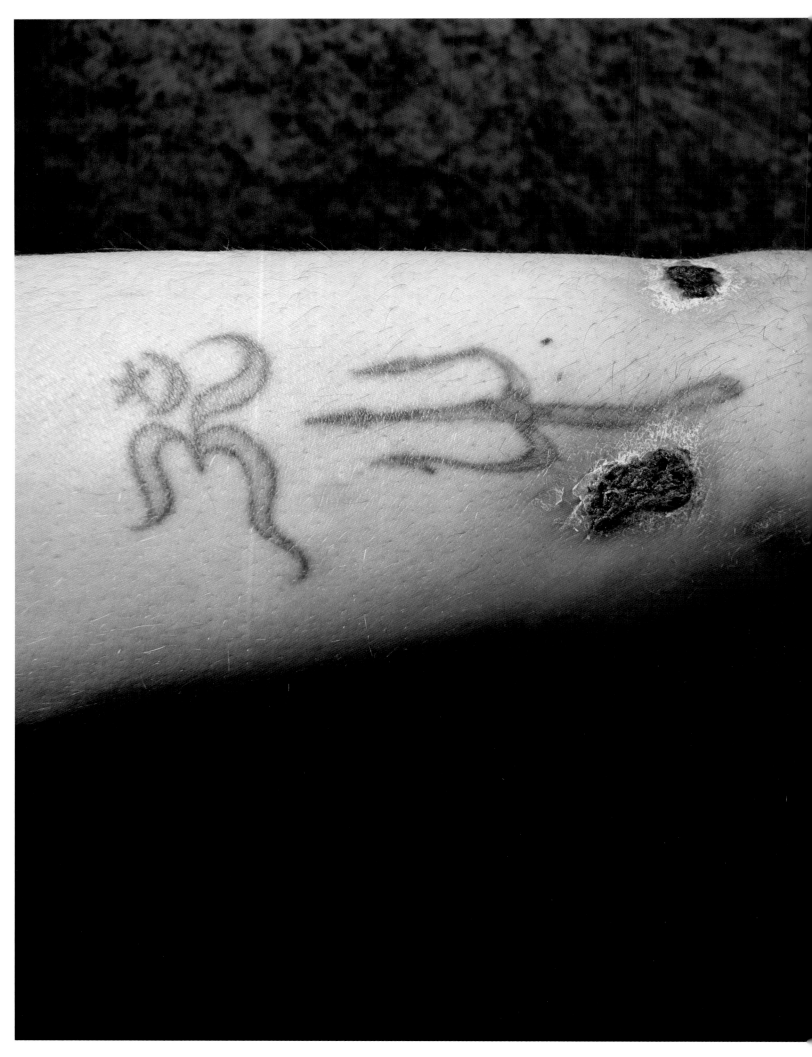

Untitled, 1995

On and Off Drugs Neal Brown

'Photography is a wonderful means of self expression, and when the taking of photographs is allied to the making of photographs in the darkroom, it leads to great fulfilment…'

Michael Freeman, *An Introduction to Photography*, Grange Books, 1995

'…Jack's got the knife to his chest like this, and cuts him again, another little slice, right? And the blood's running down his pink body … And I couldn't raise the […] camera. I was so fucked up on 'ludes that I could not raise it, and I was laughing, and I could not get my hand up, man. It was just physically impossible. I was too fucked up. And I hated myself for years, I still hate myself for not being able to take this great picture. I think this would have been one of the best pictures I'd ever took in my life. I kind of started realising that it was getting overboard, that I couldn't function so well; I mean, talk about squandered opportunities. That was starting to come into it. I was getting so fucked up that I wasn't doing my job any more.'

Larry Clark, *Teenage Lust*, 1983

'The United Kingdom Foyer movement provides accommodation integrated with education and training opportunities for disadvantaged sixteen to twenty-five year olds. Foyers were first established in France as part of the post-war movement to rebuild the economy. They were created to enable young people to move into urban areas to take up work. In the early 90s, the French model was adapted in the UK as a response to the 'no home, no job, no home' cycle. Consequently, the first UK Foyer opened in Liverpool in 1992. The movement is now one of the most effective national organisations providing these kinds of services.'

Description of the United Kingdom Foyer Movement, *Wherever You Go* catalogue, Gareth McConnell, 2002

There are, it could be said, two communities in Northern Ireland, divided by a rigidly enforced, historical sectarianism. These are the alcoholic and addict communities, whose mutual enmity derives from the paradox of an identical wish: to change consciousness through the use of mood-altering chemicals. Existing within a context of disadvantage and dejection, the divide seems, to most outsiders, a bit of a mystery – a confusion of the psychotropic theologies, where personal, public, moral and legal patriotisms collide to create stern boundaries. On one side are the alcoholics, who claim that liquor is supreme – a claim made by them until their boozed noses swell and blotch and redden, and their livers stagger and burst. On the other side are the addicts, who claim otherwise – that it is the infinitudes of peace and imaginative pleasure that drugs such as opiates and cannabis bring that are superior; a claim made in spite of the hell-fires of pitiless withdrawal or egotistical psychosis these drugs can cause.

Gareth McConnell is not, himself, claiming that any such real or imaginary divide is presented in his photographs, whether in Northern Ireland or elsewhere. But it can be difficult, when discussing McConnell's work, to resist occasional speculation, certainly in respect of such a wildly lawless and factionalised subject as drugs – and drugs do occur in his work – and especially where (for reasons of courtesy towards his sitters, perhaps), specific details of his depictions have not been spelled out by the artist.

It is on such a basis that McConnell's work will, sometimes wildly and lawlessly, be considered here – it being assumed, for example, that the artist's work is informed by his origins in Ireland. Ireland's civil conflicts, religious disputations and history of tragic subjections certainly offer, if we want them, potent analogies or insights towards the artist's themes. Dispute, division and the closeness of death, as well as idealism, beauty and a musicality of hope, are thematically present in McConnell's work, which depicts the disadvantaged, auto-destructions of alcoholism and drug addiction, mental illness, homelessness, institutionalism and violence.

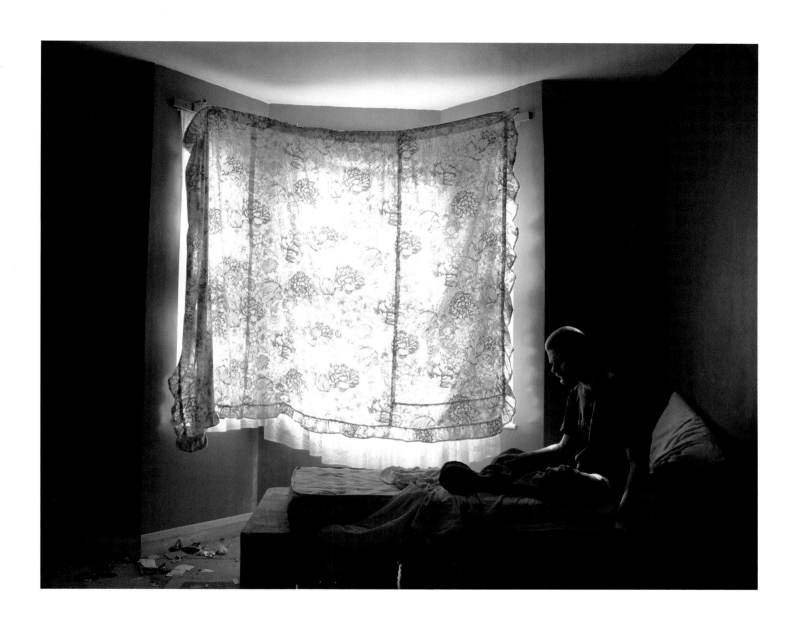

Blind Mark in the Crack-House, 2002

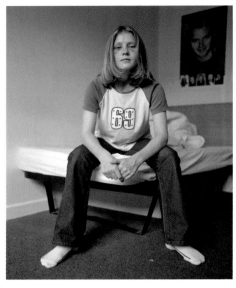
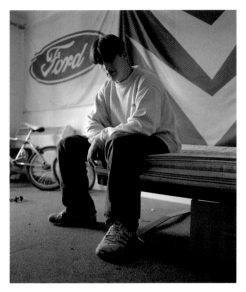
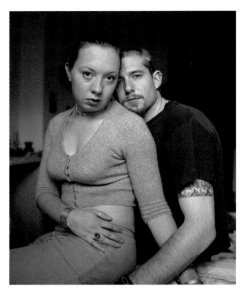
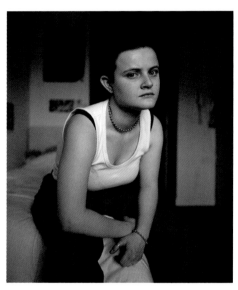
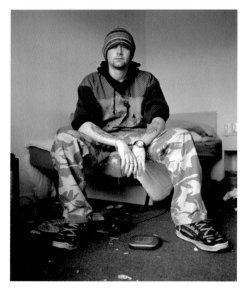
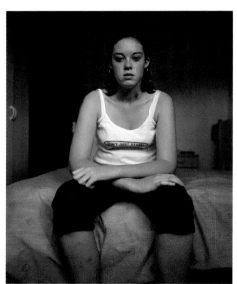
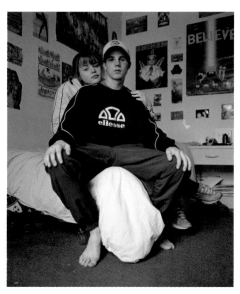
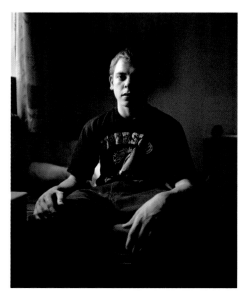
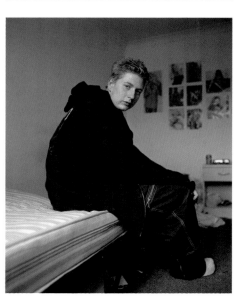

The artist's working method involves a shared, co-operative process. In a patient working relationship with his subjects, given conviction and authority by being based on his personal life experience, he accords them a dignified value and concern, in contradistinction to the often extreme misfortunes of public or personal madness that surround them. Whether drinkers in pub interiors, intravenous druggers with hypodermic needles, the young homeless or victims of violence, McConnell's are not works of a cautionary or didactic nature. In spite of the loaded moral climate that might accompany whatever it may be that he is documenting, McConnell's photographs are respectfully detached and non-judgmental; they are not the coolly ironic – or hotly exhibitionist– fashion statements of confessional or exploitative debasement that comprise other kinds of recent photographic practice.

What there is in McConnell's work, sustained by consistently high production values, and a calm aesthetic sense, is something that excels more, through being less – by being purposefully modest. Quietly offering his singular view, McConnell's work can be considered as love-positive as it is possible to be in the current times; tender without ceding visual excitement.

A constant in McConnell's work is the presence of literal or metaphorical homelessness. Most notions of place, identity and security have a relationship with an idea of home, and to be homeless is, of course, a profoundly destabilising condition. Prisons are places where access to home is denied to offenders as a significant part of their punishment – institutional home-lessness being more ably effected and absolute in its prohibition than disallowing access to sex or drugs.

Much international war-making, just and unjust, has been made on the basis of defending (or advancing the interests of), the 'homeland,' and the idea of inscribing identity with place is potent and strong. A sense of home accords with the deepest ideas of love, family and community; and, where a home or a sense of it does not exist, people will understandably seek this sense elsewhere.

Many of McConnell's photographs, such as those in the *Wherever You Go* series, which show residents of Quay Foyer in Poole, Dorset, are of homeless or institutionalised people, who have become so because of some kind of tragedy or misadventure – an abuse, a failure, or a neglect of care – either by a parent or carer, or by the homeless person his or herself. As a category, these are persons who are usually expected, in a fantastic contradiction of terms, to conform to deviance.

It's a project whose precedent includes the photographic archive of Dr Barnardo's Homes, the children's orphanages founded in the 1860s. The distinguished photographic picture editor and writer Bruce Bernard once said of Barnado's archive, that *'pictures taken with no artistic motive or intention to impress can be as interesting as any others.'* It would be a rarefied, contradictory ambition for an artist to make work 'with no artistic motive or intention to impress,' and unlikely to be achieved. But McConnell gets close to this contradiction, in his modest sort of way; creating the conditions for a quiet exactitude of documentation, being neither sensationalist or boring. It is a difficult ambition, these days, to make such works; made with meticulous precision and grace, with subtle colour transitions and obsessive attention to detail, but which lack contrivance, extreme novelty or subterfuge.

Through an empathetic process, similarities and differences between the sitters can be perceived in the work. Posing on their beds, they are in a shared accord with McConnell, who gently allows the small details of individual particularity to be seen, without didactic explanation or analysis; recording presentations of dress, hairstyle, physical manner, jewellery, bruises, tattoos and scars, as well as the props of homemaking, such as souvenirs, posters of bands and footballers, and arrangements of pillows etc. In this way ideas of inclusion and exclusion, conformity and non-conformity are given nuanced emphasis, by being arranged according to McConnell's unconditional outlook.

It's neither a socio-historical critique, nor a critique of the objectivity of photography, as say by Alan Sekula or Willie Doherty; nor is it about the fractured dysfunctions of identity, as by Gillian Wearing. While the photographs gather into focus the poignant energy of the young people depicted, they do not seek to dictate the direction to which our response should be

channelled, allowing us a temporary, meditative rest upon a poised, gyroscopic epicentre of calm.

At this point, imagine a confused, speculative reverie … a tap on your door at 3.45 am… Communities devise their own strategies of social control independently of the legislative commands of the state. In Northern Ireland there is a tradition of punishment beatings and shootings, for political or social transgression. For anyone – but especially an alcoholic or addict, or maybe an artist – stigma, social ridicule and embarrassment are also an extreme punishment, at least for their maimed ideas of ego-glory. There are also categories of dysfunctional persons, many of whom might prefer a vicious and nasty beating to having the cut and style of their trousers ridiculed.

Violence has an ugly equivalence, whether a punishment beating, as depicted in McConnell's *Antisocial Behaviour Part I* (1995), or the self-inflicted wounds of intravenous drug use in *Antisocial Behaviour Part II* (1995). The psychology of politicised internecine violence, artworld sectarianism, or the self-violence of addicts are, all of them, deeply confusing, and characterised by degrees of hatred – involuted self hatred – that can amount to an auto-destructive suicide.

…There is a another tap on the door. Which you now, slowly, pull open …knowing who is going to be there – a psychopath with fermenting breath and too much beer inside, someone who is both Republican *and* Loyalist, and who informs you that you are considered a burden on your community. It is you. THE PERSON AT THE DOOR IS YOU: YOU HAVE GRASSED YOURSELF, AND YOU ARE GOING TO BEAT YOURSELF UP. Holy God – not only are you the wrong religion, politics or faction, or a druggie instead of an alkie (or perhaps a figurative painter, whereas you should be a conceptually based visual artist, working in photography, or vice versa), but your trousers/ cardigan/ skirt *are* indeed quite, quite wrong. You are deeply uncool, AND YOU ARE GOING TO BEAT YOURSELF UP …

Thus insulted, your low self-esteem or helplessness requires you to bow to the inexorable righteousness of a profoundly negative auto-destruction, which means there is no exit out back

– no lightly jumping over the garden wall as is done in films. Silhouetted in the murderous sodium streetlight you stand, the two yourselfs, each looking at the other, in an ancient complicity of divided torment. Into the rain and cold you go – maybe observing out of the corner of your eye something incongruously inappropriate to your situation. Something like *Night Flowers,* (2002) whose strange beauty causes you to wince.

On you go, each of the two of you, to a place where you will inflict on yourself crude agonies of pain, of such miserable effectiveness, that you may be permanently disfigured, mentally and physically; suffering a trauma so severe that you may – blessedly – lose consciousness, or worse: perhaps lapse into coma, or bleed to death …motherless, fatherless, alone.

It may be a little controversial, but many people now consider fashion and advertising photography to have exceeded their welcome as an occasional, visiting guest to fine art practice, and to have sought to subsume or displace it. In this view, one which is intolerant of whatever it considers to be artistic superficiality, the fine arts have let their visitor take them from behind – not just allowing the hem of their garment to be touched, but passively tolerating the crafty raising of it above waist level, losing their chastity to a humiliating public intercourse.

How might the fashion–intolerant lobby imagine the response that greets McConnell's *Antisocial Behaviour Part I*, hitting the screen of an art and style magazine. The editor – on his second Twix of the day – excitedly trills out a gasp of ironic pleasure, calling to his colleagues to come gather, and see what has arrived; impeccable images of rotund, comically asymmetrical legs, the left one studded with neat delicacy by a bullet-hole scar.

But it's the white socks that excite involuntary shudderings of an exquisitely fine, unarticulated pleasure. Unarticulated because the codes of British class and fashion prejudice dictate not only that there be a forbiddance against the repellent error of white socks – at least as seen on the working classes – but also that this forbade should be silent, the fashion elites not wishing to be misunderstood as trying to be superior to the working classes, and being misrepresented as displaying elitist prejudice.

White socks cause a revulsion that is literally almost unspeakable. 'The socks! The socks! The horror, the horror…' swoon the art connoisseurs to themselves.

Another response to this photograph of McConnell's might be that, in its apparent simplicity, it is a carefully crafted monument to anonymous pain, and a testament to nature's wish that all things should, wherever possible, heal, recover and regrow. Not another photograph of the sophisticated retro-ironies, it is a restrained study, a cross between a forensic science photograph and …well, not quite a Mantegna – an alabaster-skinned *Sebastian* – but more a conservator's photographic record of a piece of restored marble statuary, previously vandalised, and now returned to its proper and whole unity, even if imperfect.

Blind Mark in The Crack House(2002), comprises two studies of the incandescent beauty of light, given emphatic poignancy by being taken by McConnell in the home of the blind drug addict depicted, a man who, himself, has never seen light. Not so simple or facile a work as to place hope and despair in a literal contradistinction of light and dark, it is, still, a summoning of both the positive and the negative, in an extreme equilibrium.

Does the chronology of McConnell's photographs correspond with his biography? Did McConnell know Blind Mark? Journalistic convenience would like to answer yes, for the easy handle this would give the reader; providing an easy to read trajectory from the debasements of the artist's 'my-drug-hell' to a commendable abstinence, and the well-earned approbation of the art world – prestigious books, shows and catalogues.

Scholarly and prudent reflection might say the answer is not known – we may not be privileged with all the information we need to form an opinion. That to assume so might not only be premature, but possibly incorrect; 'commendable abstinence' could, next week, be a Nan Goldin-Richard Billingham-Larry Clark sort of dark, relapse kind of thing, or worse.

Actually, the answer is that McConnell did know Mark, and took Mark to live with him for two weeks to help him clean up.

Compare the depiction of interior space in *Blind Mark in The Crack House* with *Community Meeting Rooms* (work in

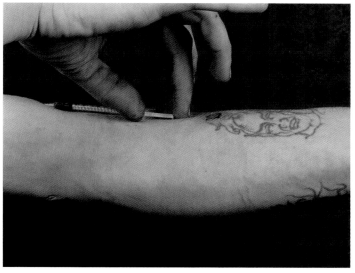

Antisocial Behavior Part II, 1995

progress). All sparse, depersonalised, functional spaces, all spiritually transient – although the traffic does go in a different direction in each. Everyday, everywhere, huge numbers of people gather in neutral spaces kindly provided to them by churches, schools, community centres and other social institutions, to meet, talk and to interact; yoga classes, drugs and alcohol recovery meetings, discussion groups, exercise clubs, classes, choirs etc.

McConnell's photographs, of the unglamorous rooms where these events occur, are of places which do not make money but instead create the conditions of hope and socialised purpose, and whose anonymous service is usually regarded as too embarrassingly sincere to be remarked.

Antisocial Behaviour, Part II (1995), are works that show the self-inflicted wounds of intravenous drug use. One of these is of a needle daintily introduced into a user's arm – the user's nicotine patinated little finger crooked outwards, like that of a

Home Counties wife holding a bone china teacup.

It's reminiscent of D. H. Lawrence's Poem *Mosquito*[1], an address to the eponymous insect as it takes its dinner.

Lawrence wrote:

> '...*you shall lift your centre of gravity upwards*
> *And weigh no more than air as you alight upon me,*
> *Stand upon me weightless, you phantom...*
>
> *...I behold you stand*
> *For a second enspasmed in oblivion,*
> *Obscenely ecstasied*
> *Sucking live blood,*
> *My blood.*'

The mosquito's itch is caused by its need to keep blood flowing, the insect introducing a decoagulant into its dinner's arm. The consequence of this is, (1) that as well as getting dinner, mosquitoes are often cited as evidence of the non-existence of God (or that God is a bad designer), (2) that a good poem has come to be written because of one individual of the species – Lawrence's poetry, including *Mosquito*, is regarded by many as greater than his prose. (Interestingly, *Mosquito* also seems to anticipate Sylvia Plath). If there was a (3), it would digress a bit, unnecessarily, and state that another poet, Rupert Brooke, died from a mosquito bite, his blood being poisoned by an infection caused by the insect's sly puncture – Brooke having survived, until then, the trenches of the First World War.

And finally, if there was a (4), which there isn't, it would claim, from all of the above, that a highly developed awareness of the visible world can create a poetry of emotion – as does McConnell – and that this is a positive counter irritant against the revulsive, fearful things of the world.

Most folk continue to wish to believe in photographic truth, even if it is now a commonplace, persuasively argued, that such truth is, at best, a variable, and the abandonment of it even a cause for delirious celebration. Photography's implicit instruction that 'it is possible to believe this image, it is true, and it is veracious' is now deeply mistrusted – although the idea does persist in reflecting itself back from photography's shiny paper surfaces. Trust and credulity have been disputed and questioned so much, however, that what was once a reasonable scepticism may have overshot its own truth, and become a sort of tragic chorus. The falsity of photographic truth has been so endlessly repeated by commentators – Barthes, Debord, Baudrillard, Sontag et al – that it is tempting to argue against them, just for the hell of it.

Through such seditions, the old understandings have been overturned and we have arrived at the strongly held belief that photography is a sort of free floating, relativist plurality of image merchandising[2]. Which (apart from the many times when it actually *is* merchandising), it is not. Or would not be, if it were not deliberately and artificially made to serve other, more vain interests; editors, journalists, publishers, advertisers, politicians, business people, philosophers, artists, critics, art historians, curators, arts administrators, writers and even – especially – photographers themselves.

All these, to put it simply, have a venal interest in photographic untruth, and so are the liars, rather than photography itself – the moral being: photography GOOD; photographers and liars BAD.

Maybe work like McConnell's should be advanced as representing a correction, a photography that aspires to a more benign, self-certificated neutrality of truthfulness than might be thought possible – a photography placed more at the service of its community, and which, as far as possible, makes its agenda one of clinically respectful detachment. In such a view, rather than just disputing photographic veracity, there could be an increased raising of an expectation that photographers – like other people holding important positions of public trust – should practice more truthfully, and with a greater spiritual responsibility.

Integral to photography, and what gives photography part of its critical importance, is that it has a monopoly on the visibility of death[3], which it mediates for us. A society like ours, without

visible death, where corpses can rarely be seen – even a dead cat in the gutter is quickly whisked away in the West – is not, as we like to think, a successful one, but is actually impoverished. A properly complete spiritual outlook requires that we be close to death, or the deathlike, in its most proper actuality.

We are shown images of many kinds of death, especially of the dead that come from the other side of the world (as, for our comfort and convenience, they tend to). And, as we know, this is a kind of exploitation, inconsistent with our treatment of our own dead who we do not allow to be seen. Showing death is what photography does for us, in what could be called its religious duty. In return we have let photographers get away with too many lies, in the same way as other priesthoods have been overtolerated their sexual hypocrisies. Others say that when we see photographs, like McConnell's, of death and trauma, we quickly realise we are powerless – for whatever number of reasons – and so become despondent or inured.

So, is McConnell's work exploitative? Do his photographs engender a sense of hopelessness? McConnell's work certainly addresses the deathlike; people who are, or recently were, on the cusp of extinction. *Antisocial Behaviour, Survivors, The First Man to Remember My Name, My Grandfather's House* are a unity of meditations on death and finality, qualified by the artist's own experience and proximity to them, and given contemplative effect through his stilled viewpoint.

McConnell is describing a place he has been himself; a journey he has, or is still, making; a place to which he is more a participant than a bystander/ witness – more than just a tourist visitor or voyeur. For this reason his work cannot be said to be exploitative. And, although it is a horrible place he has been, and which he looks back upon, and although he is not the first photographer to have been there, his report is different because of its degree of completion. He has advanced his journey further and is exploring the more difficult, less obviously photogenic area of the peace-building and reconstruction that must take place after the war.

A positive view of work like McConnell's is that it contains an encouragement: a non-prescriptive encouragement of the possibility of positive change. If we are shocked by a photograph of something death-like, or brutal, or negative (and if we are able to trust the photographer sufficiently), then our response can be one of a strong, meditative energy – shock or discomfort becoming a tool, available for use as an actionable belief towards change. And if this energy is considered as part of a moral system – a moral ecology – then, even if our action is non-specific to whatever suffering we saw depicted, it still follows that a negative cause and a subsequent positive effect are related. Whatever our circumstances allow us is what we should do, so making a valid and true response possible – a response to whatever harrowing or beautiful image it is that McConnell may be showing us.

1 D.H.Lawrence, *Birds, Beasts and Flowers, Secker*, 1923.

2 In respect of this, and in the context of a discussion of photographic veracity, mention should be made of what is effectively a new revisioning by Susan Sontag of her highly influential book, *On Photography* (1977), in her recently published *Regarding the Pain of Others* (2004). The effect upon Sontag, and other New Yorkers like her, of the World Trade Centre disaster, and the consequence of this on intellectualised opinions of photographic superficiality and other theoretical outlooks, especially concerning depictions of death – we have seen no photographs of dead New Yorkers – must be considerable.

3 In this context, and just to be contrary, it should briefly be noted,(1) that there is currently an indefatigable lobby who argue that an American spacecraft did not land on the moon, and that photographs showing this are faked. (2) That the enduring debate concerning Robert Capa's *Death of a Republican Soldier* (about whether it depicts an actual death or not), seems to have become an analysis out of all proportion to either its historical, intellectual or conscience value (Robert Doisneau's cynical set-ups of Parisian lovers seem a more genuinely photographic evil). (3) That the botanical sciences still prefer drawings over photographs, for their clarity and emphasis.

Survivors

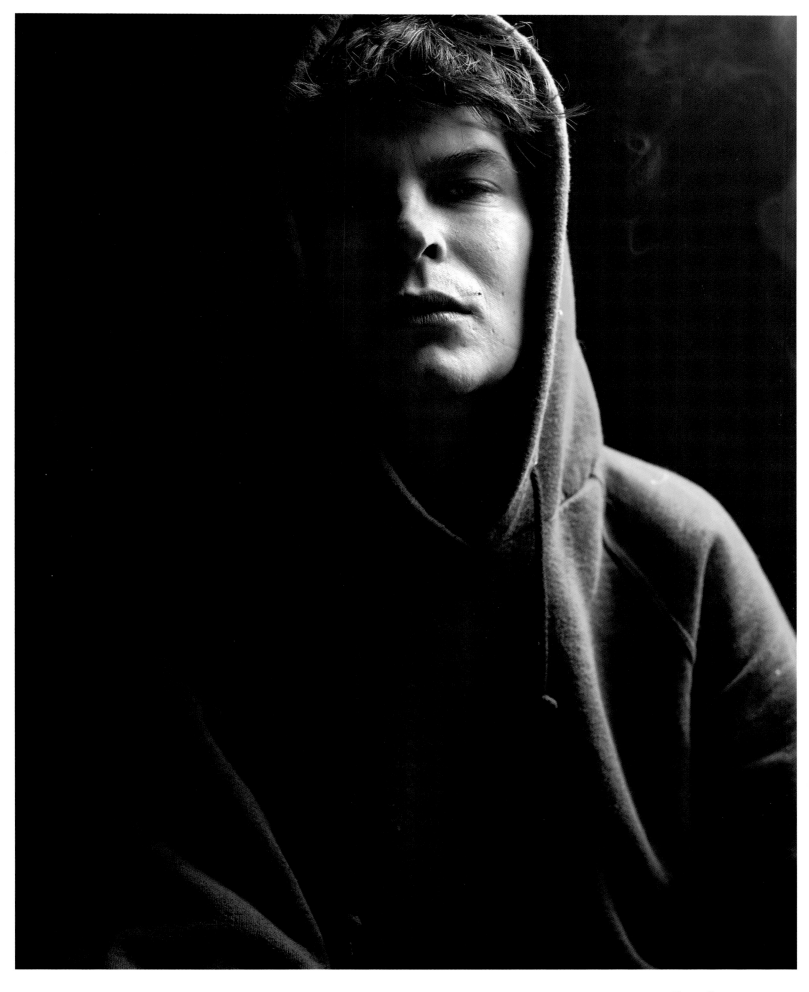

Pretty Pete, 1997

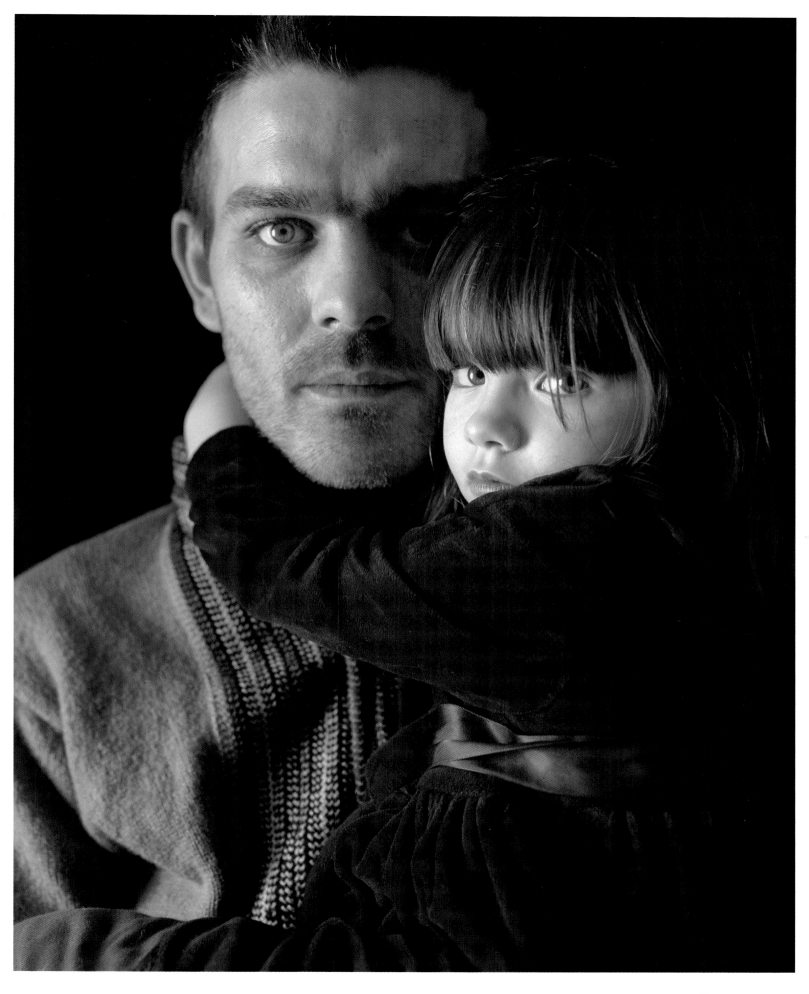

Dave, 1997

Portraits and Interiors from the Albert Bar

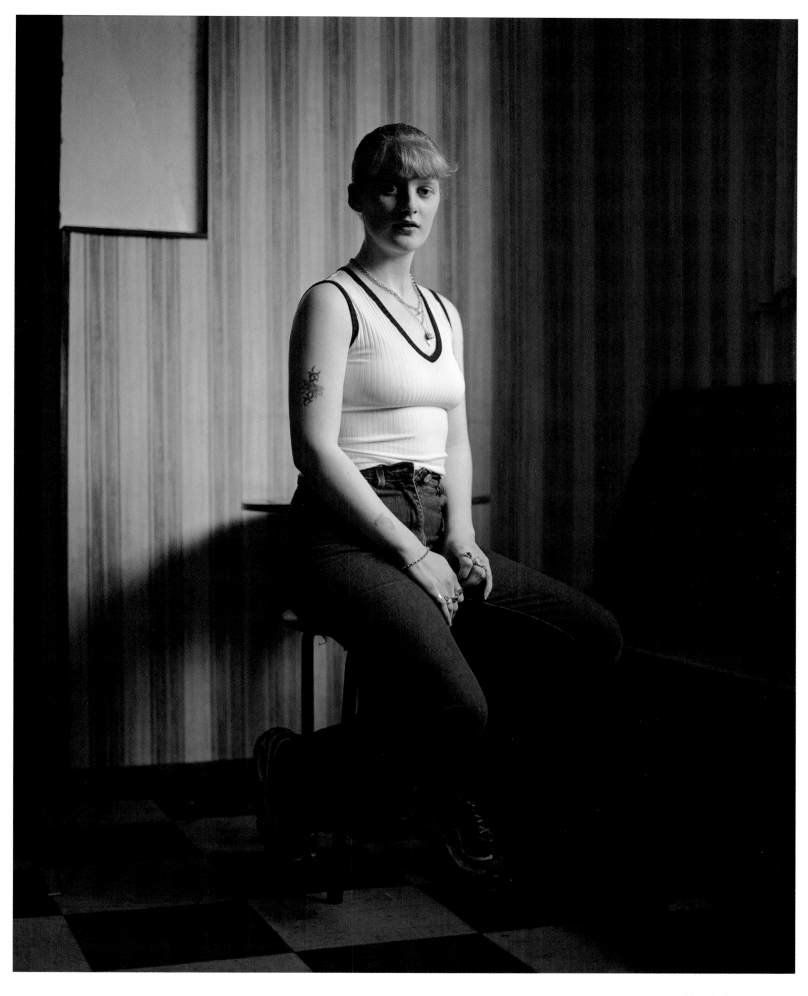

Untitled, 1999

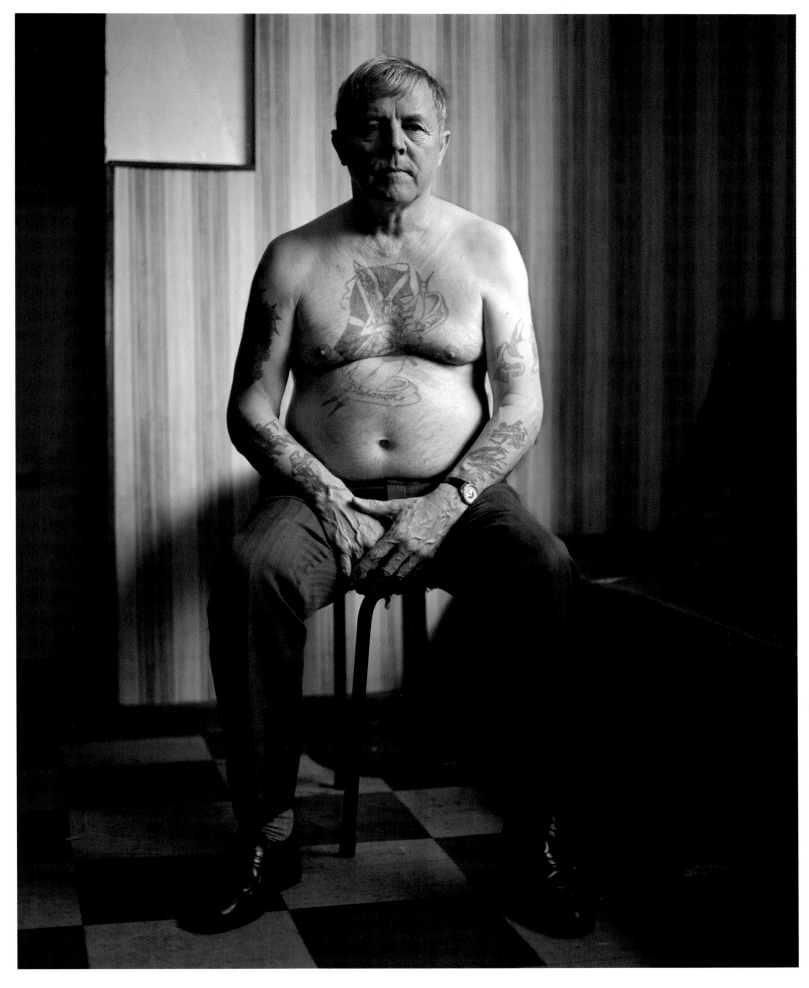

Untitled, 1999

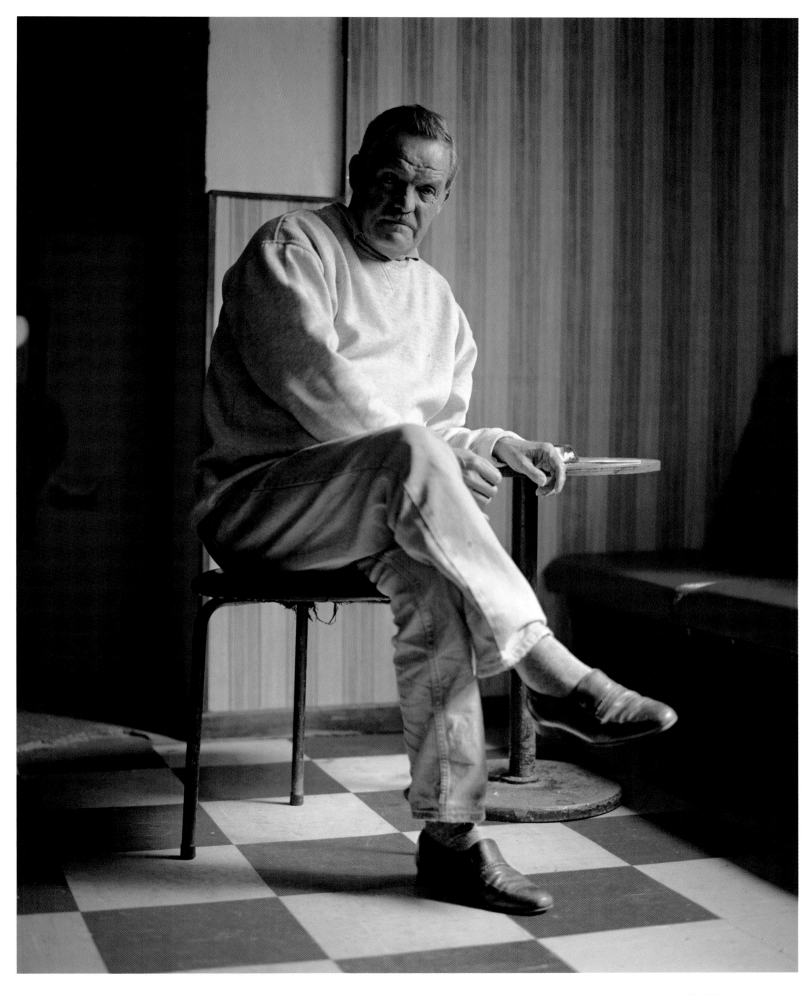

Untitled, 1999

Untitled, 1999

A View of Carrickfergus Castle & Harbour, 1999

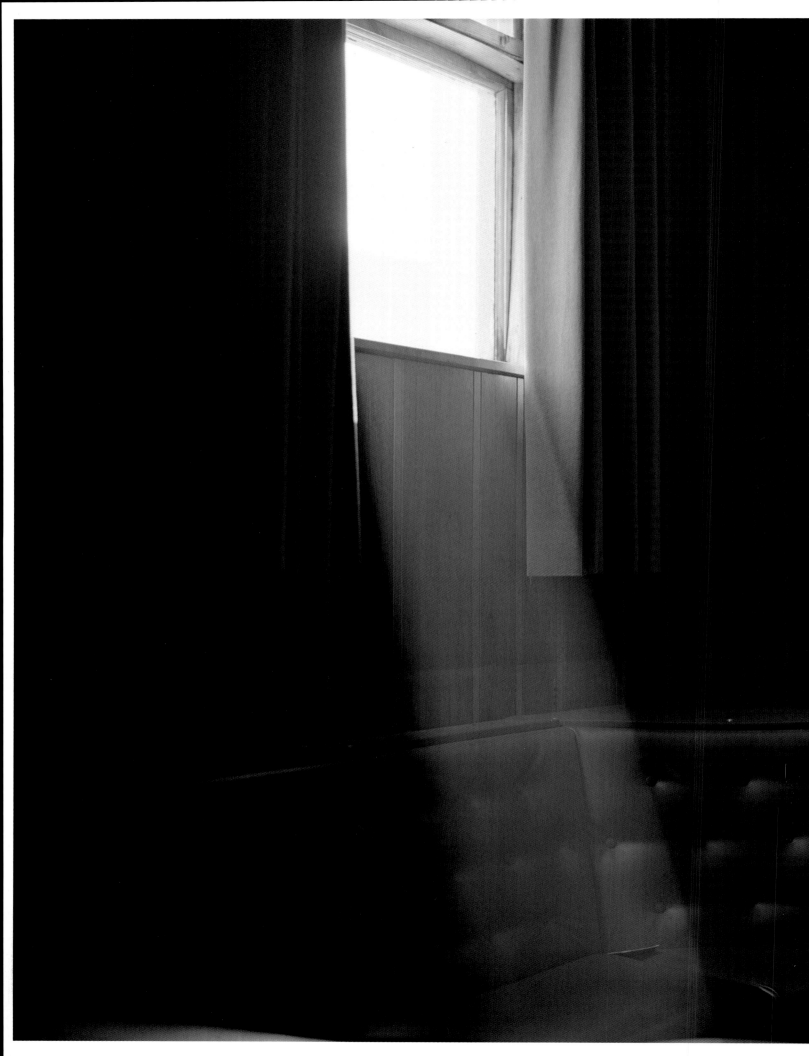

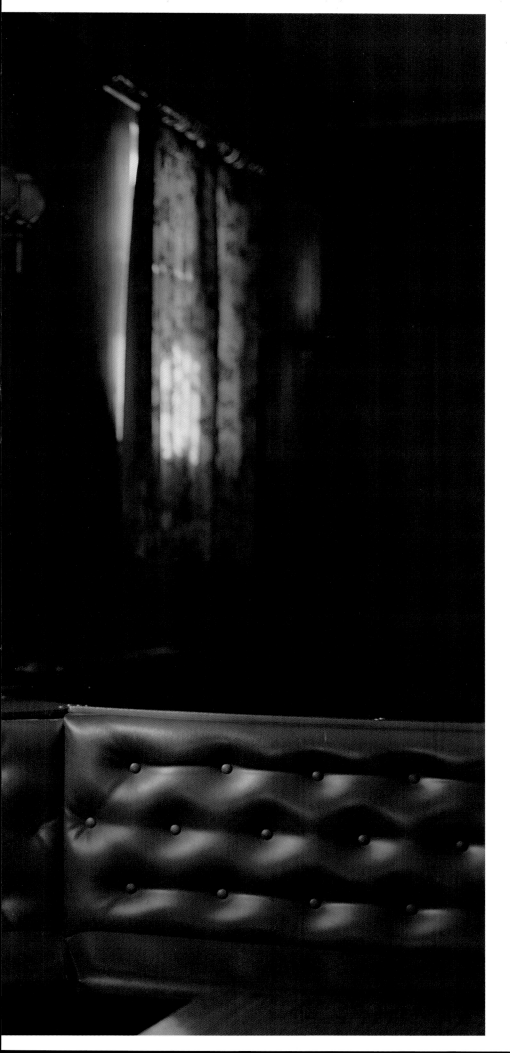

Untitled, 1999

Institutions

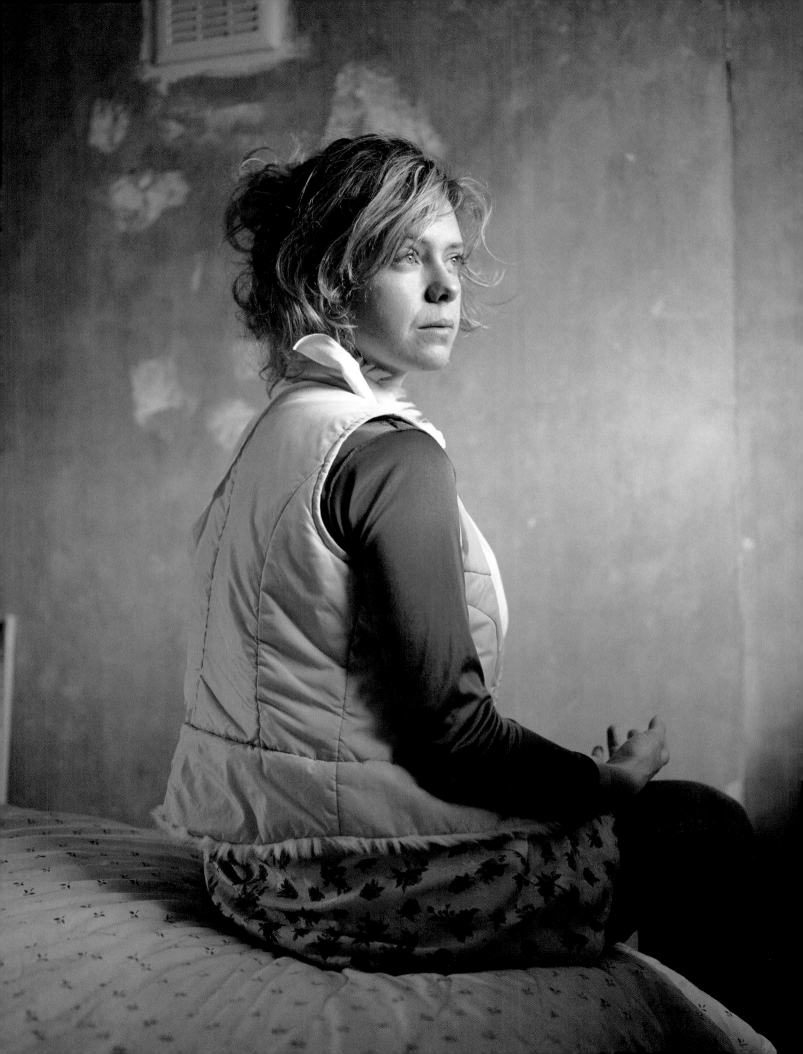

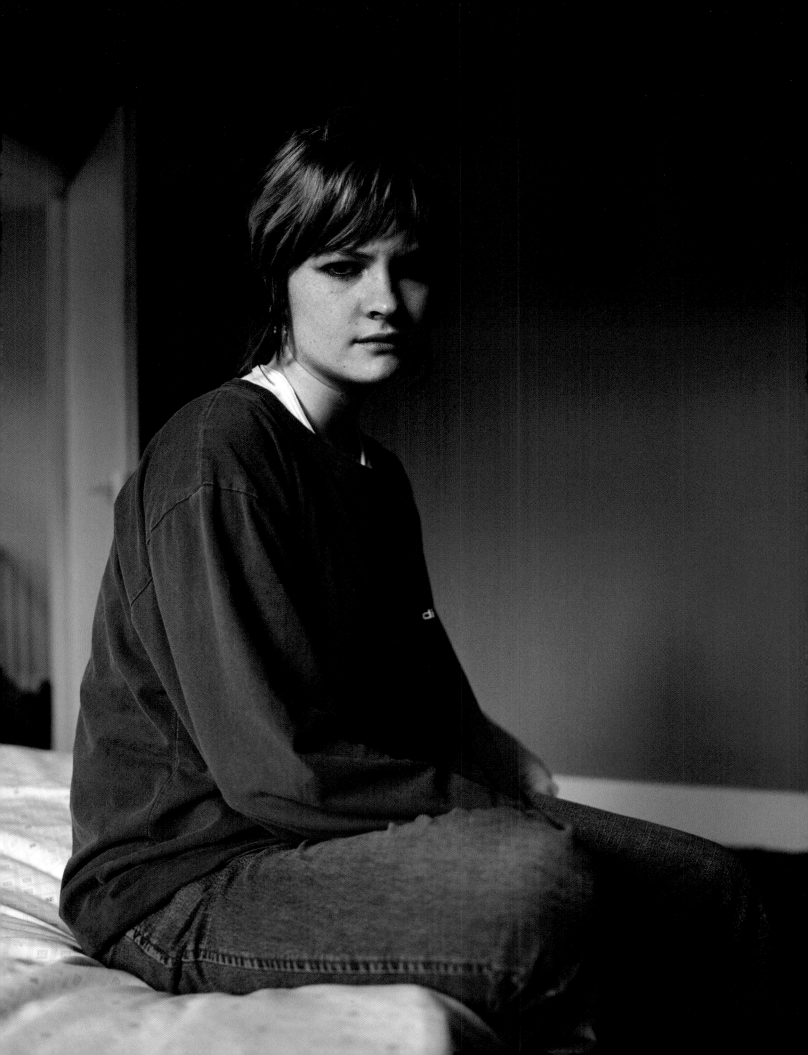

Mark, 2001

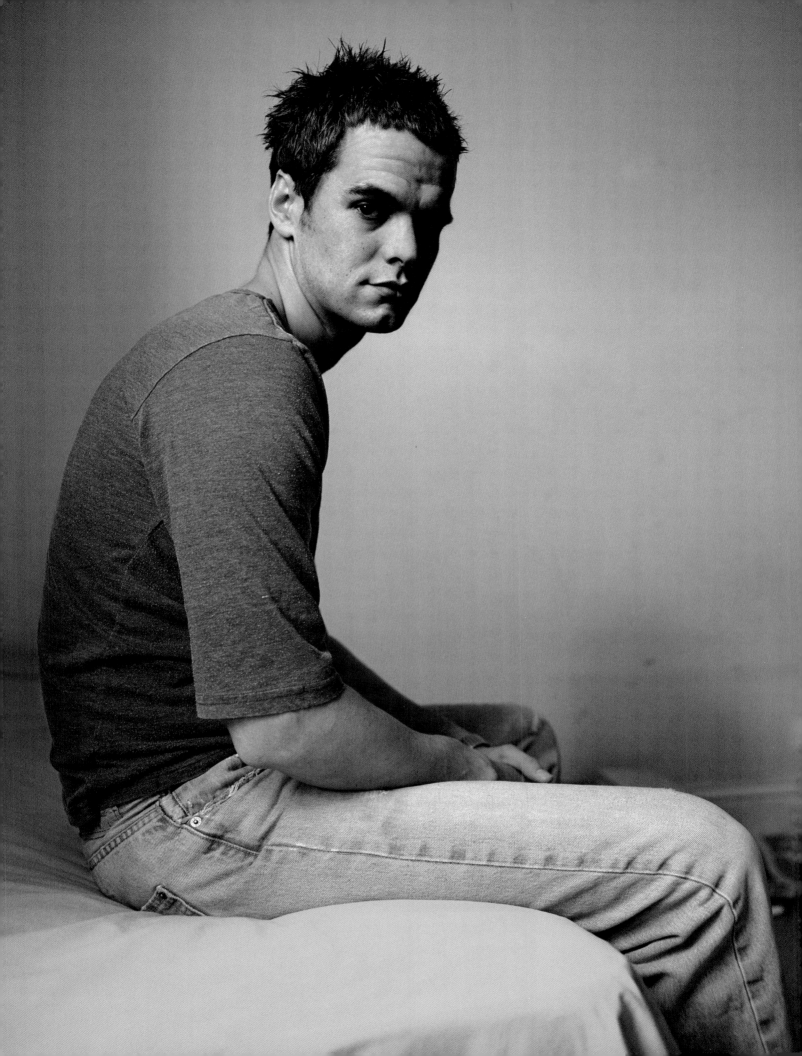

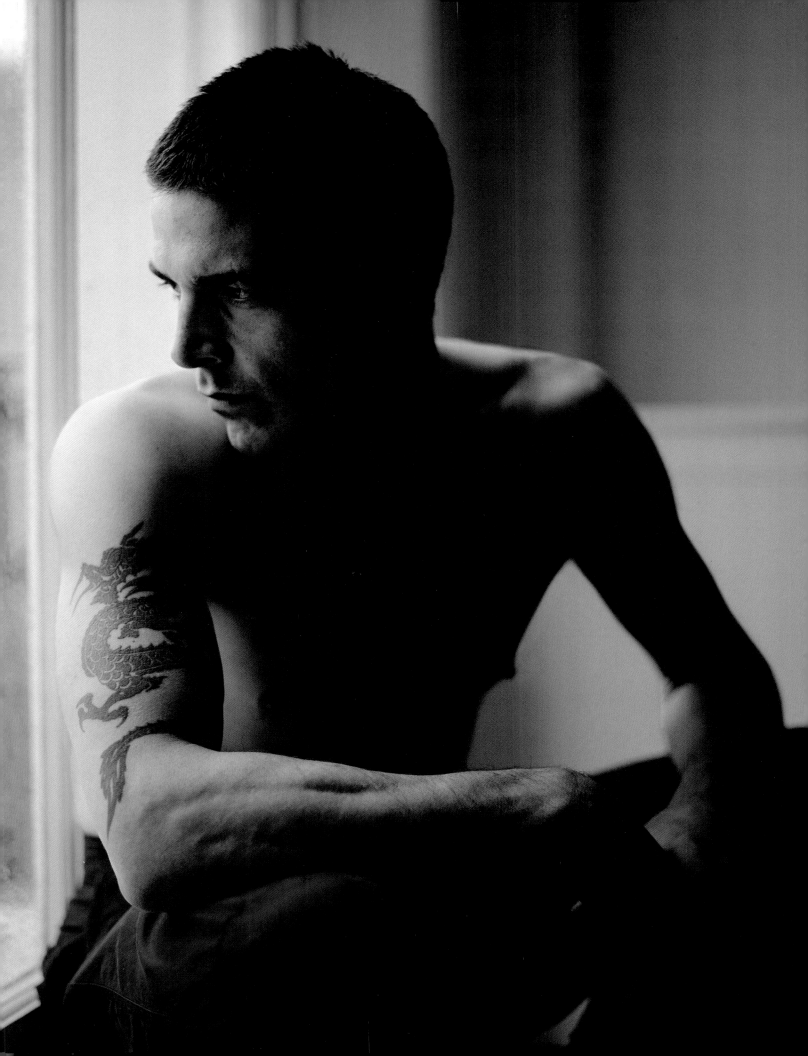

The First Man to Remember My Name

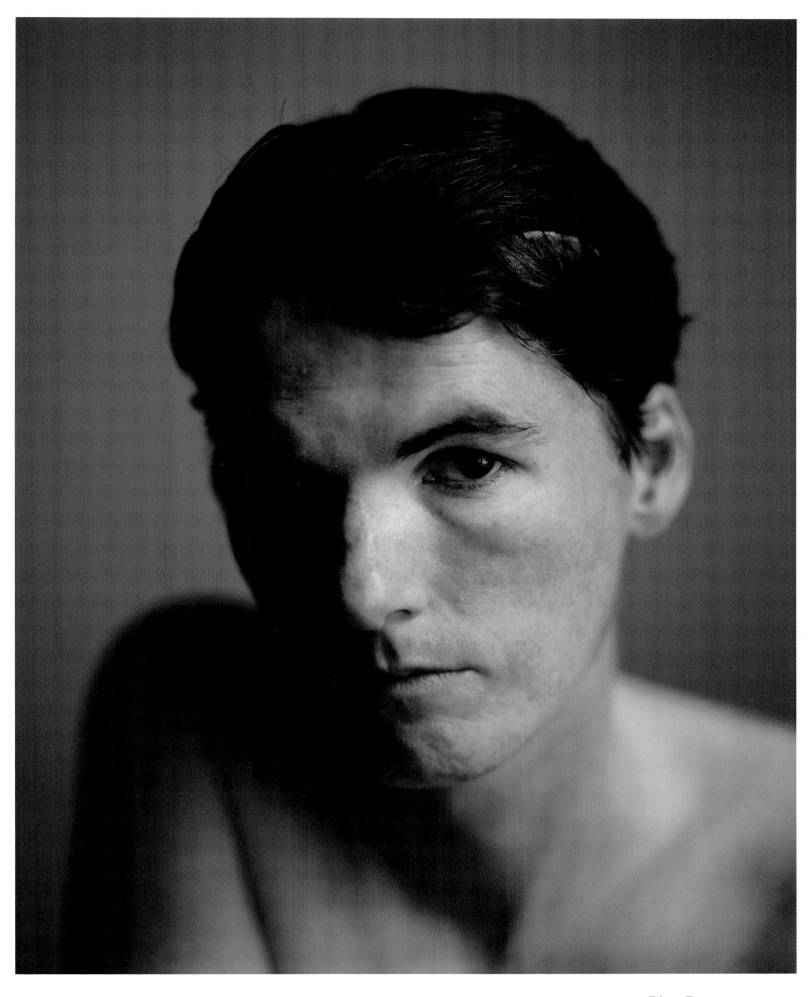

Film 1 Frame 4, 2001

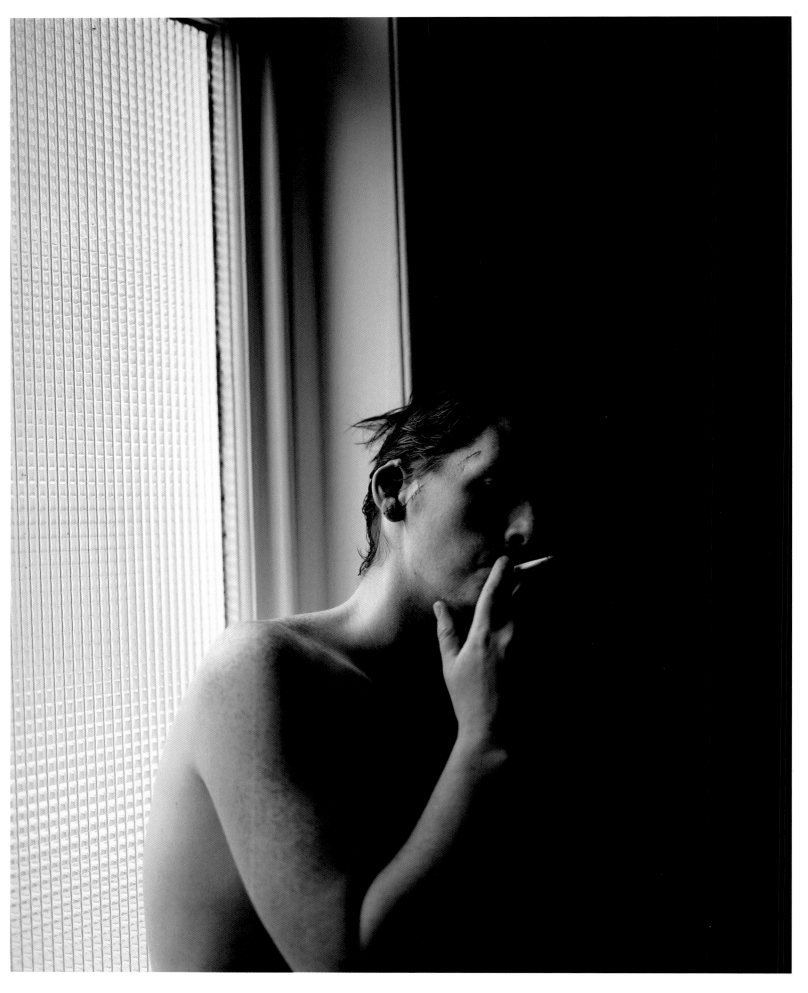

Film 2 Frame 5, 2001

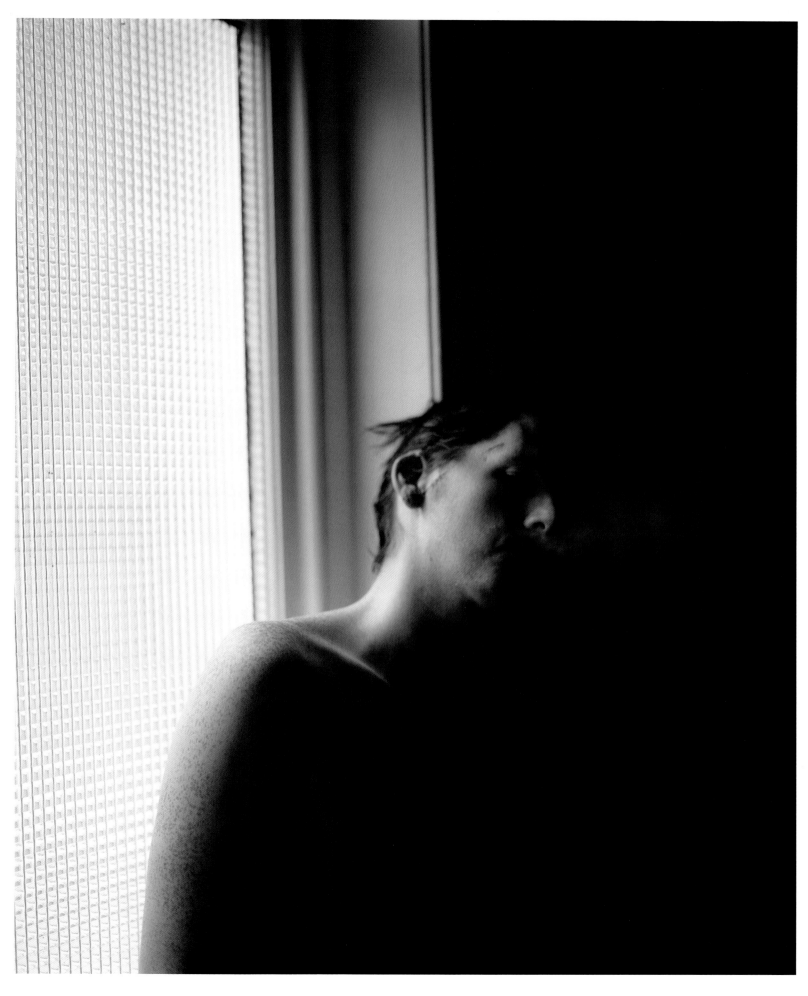

Film 2 Frame 6, 2001

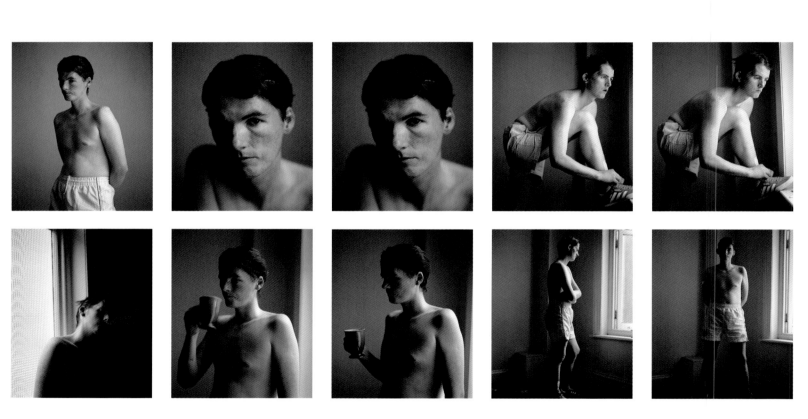

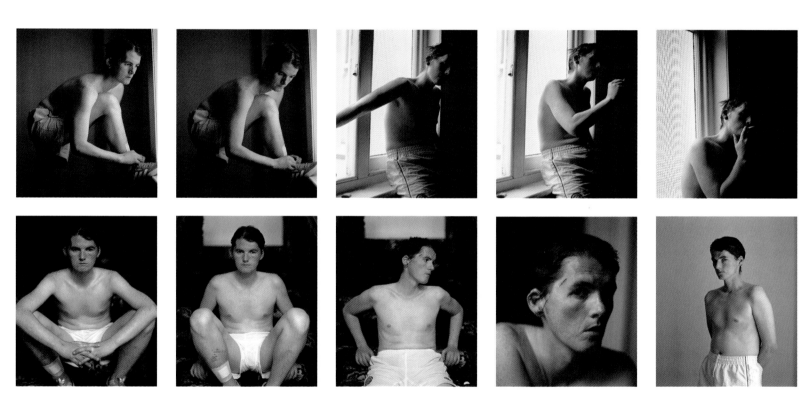

Boxers

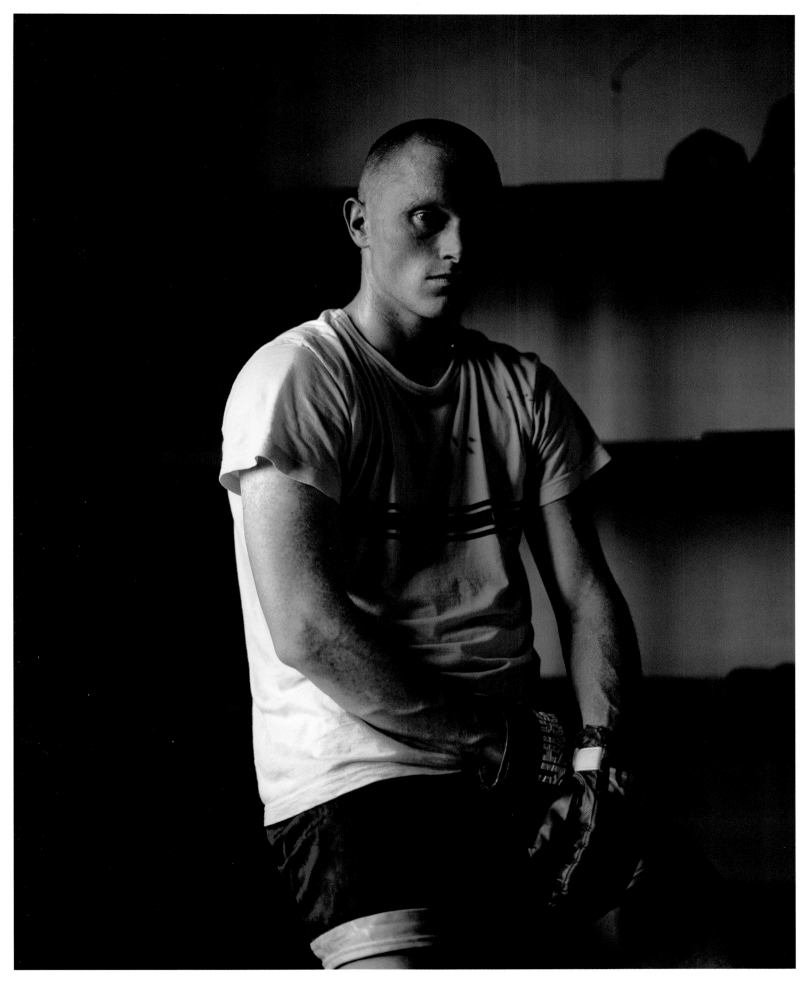

Ryan, 2001

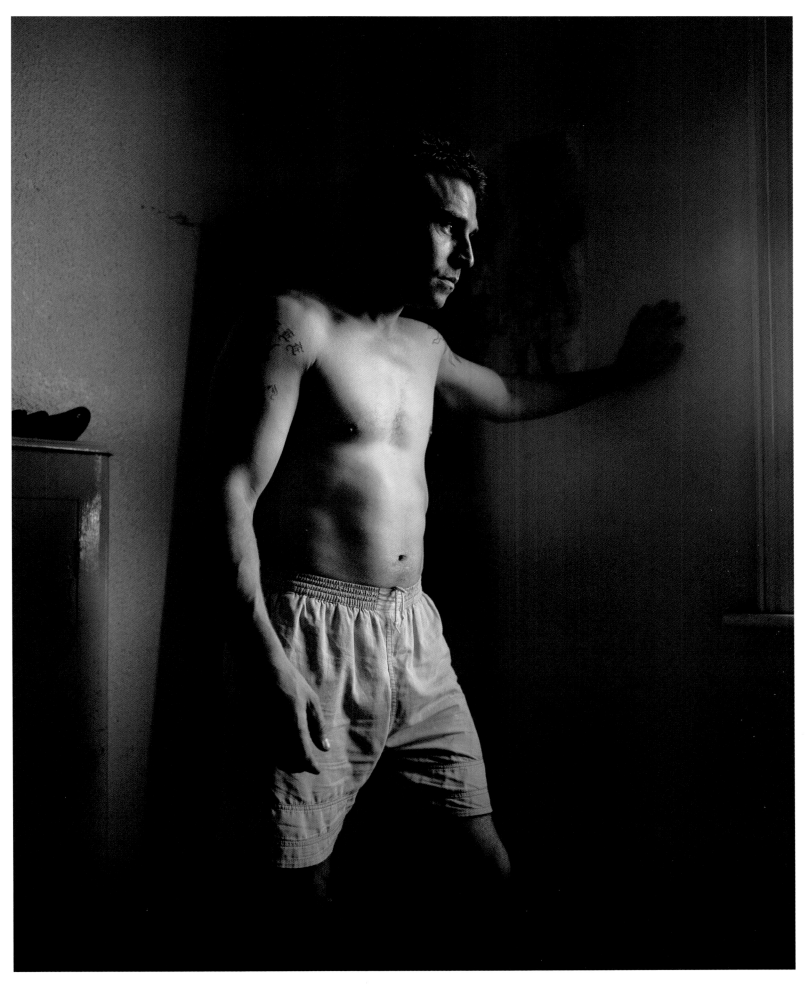

Dean, 2002

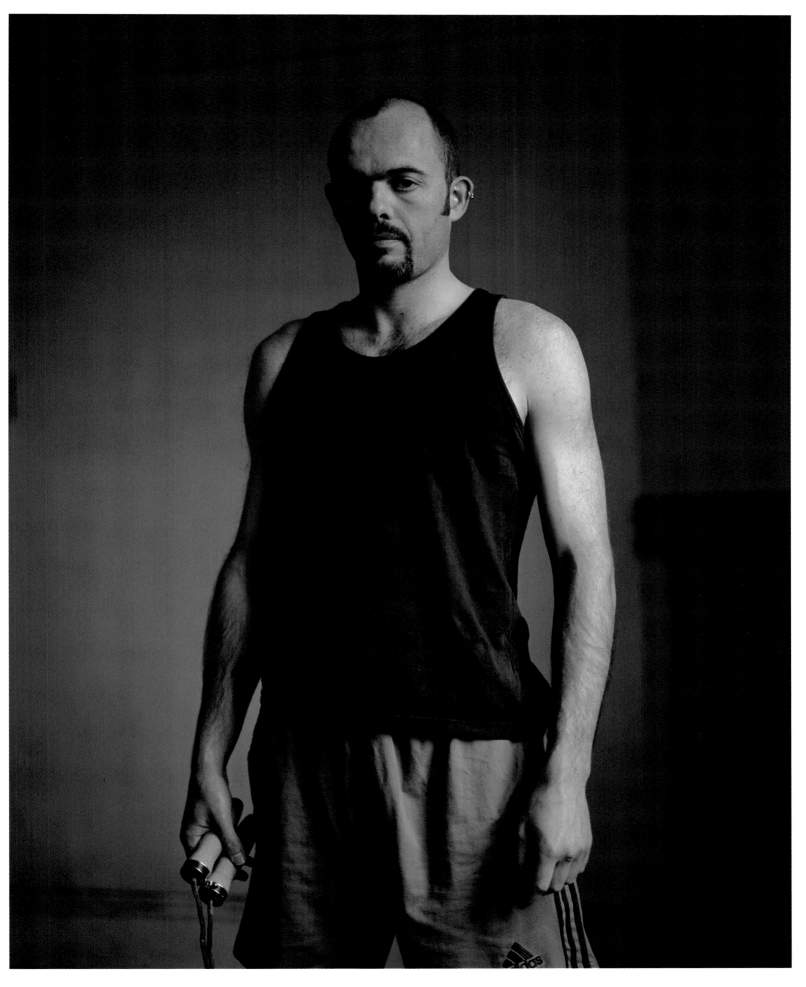

Tony, 2001

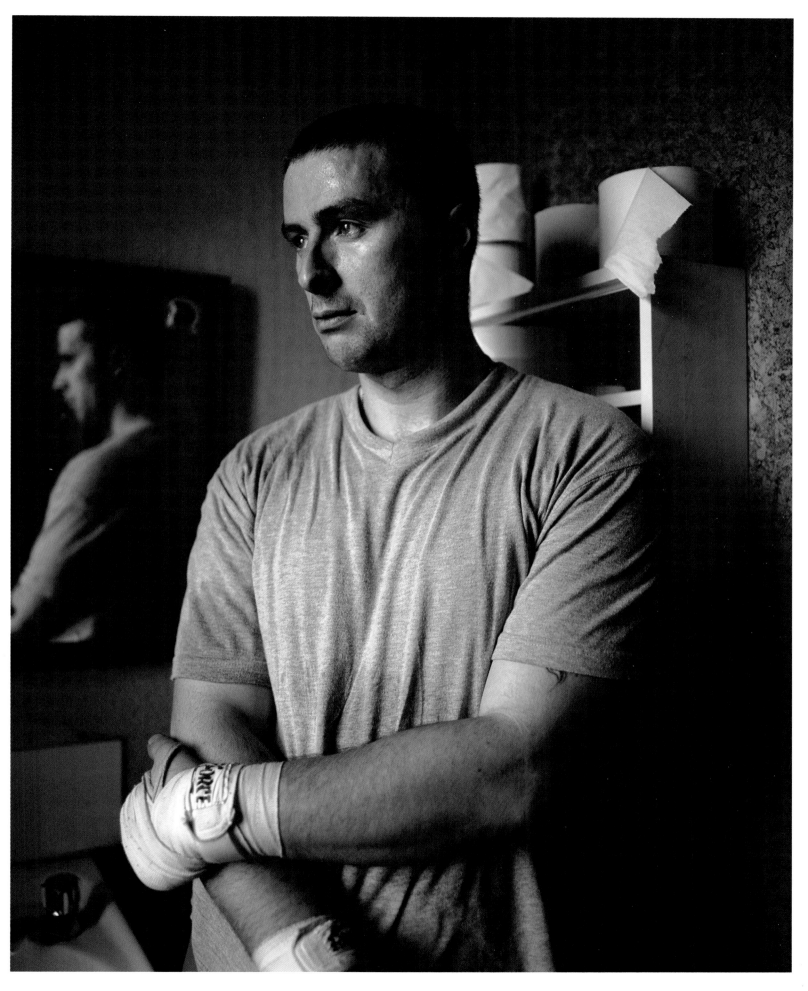

Mickey, 2002

Night Flowers

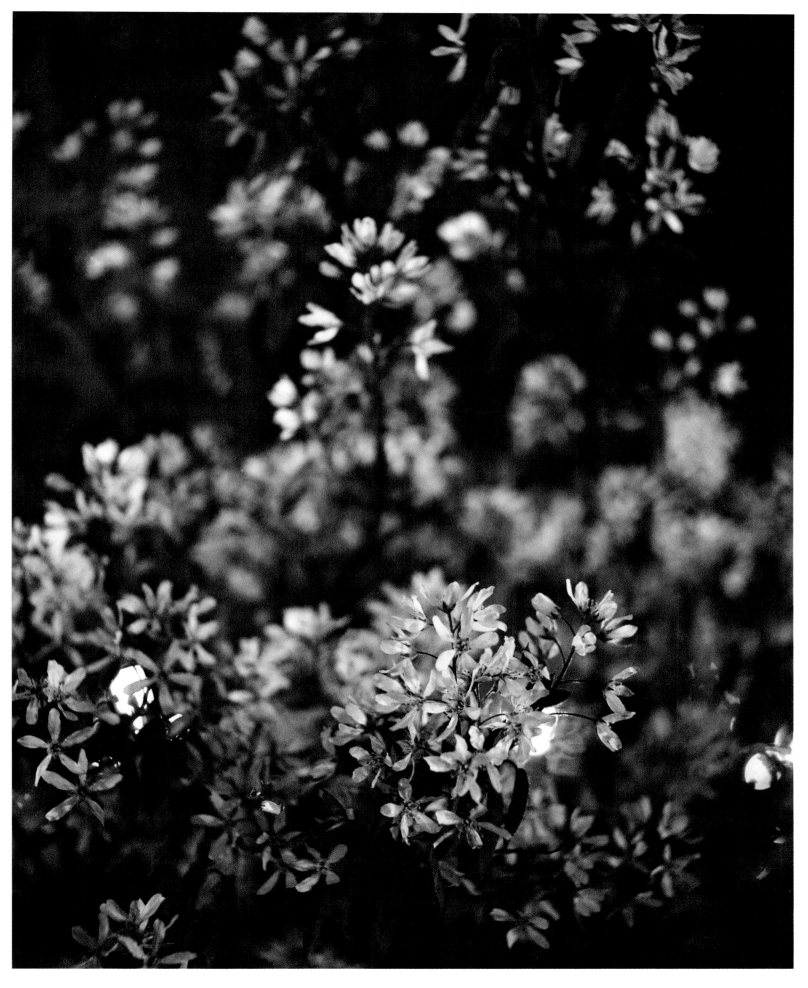

Untitled, 2002

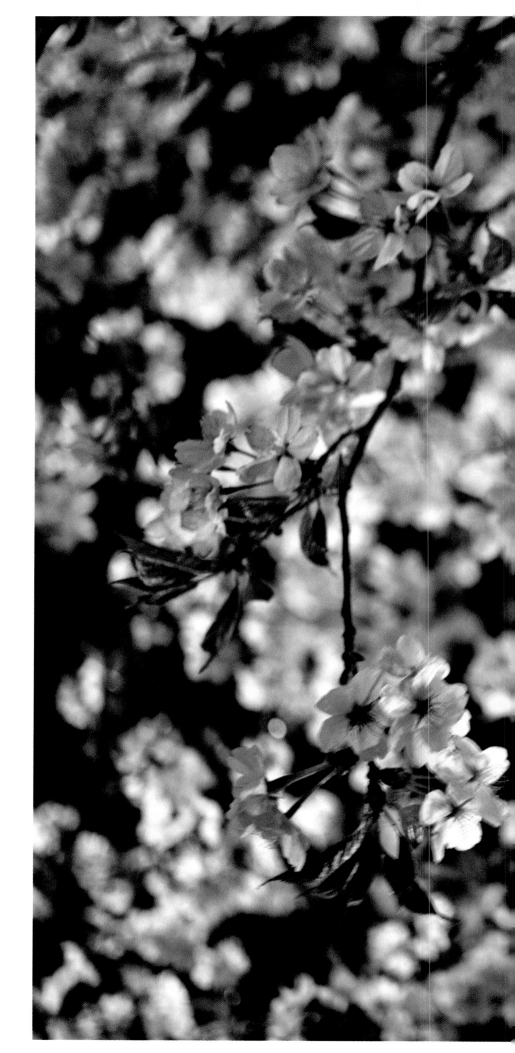

Untitled, 2002

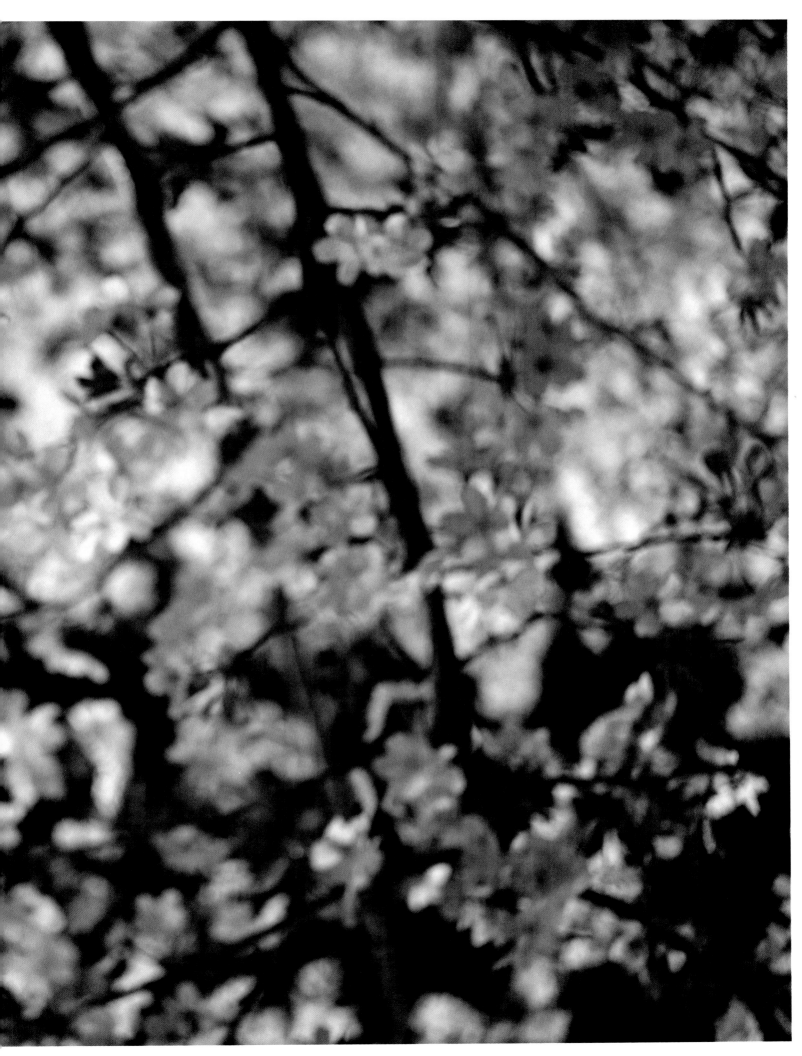

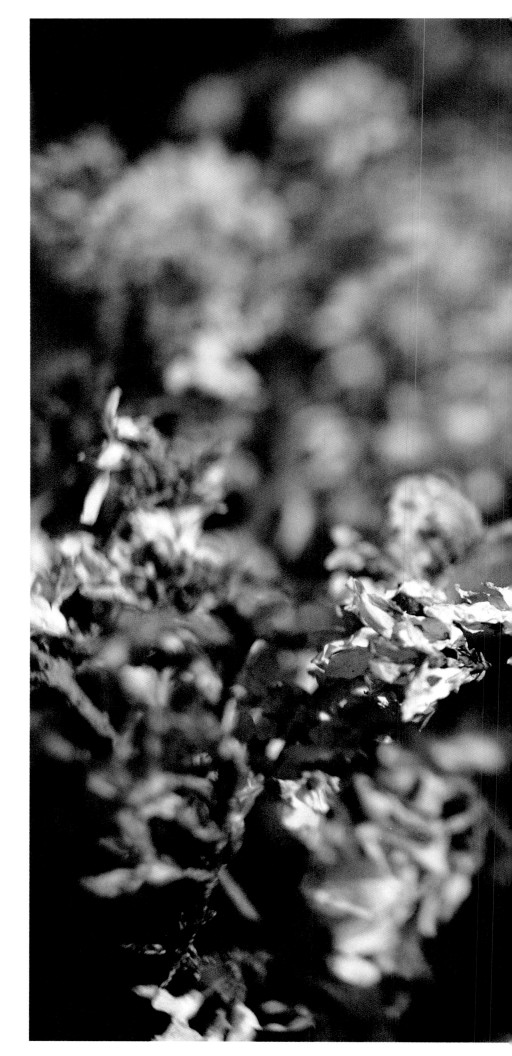

Untitled, 2002

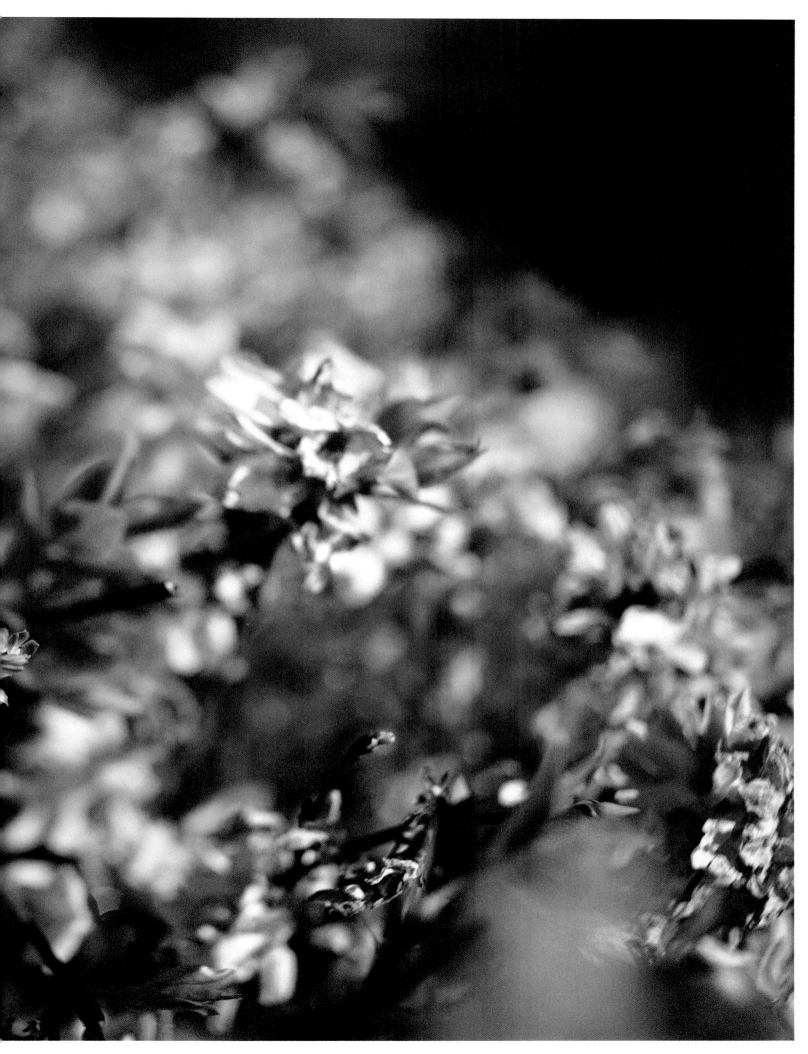

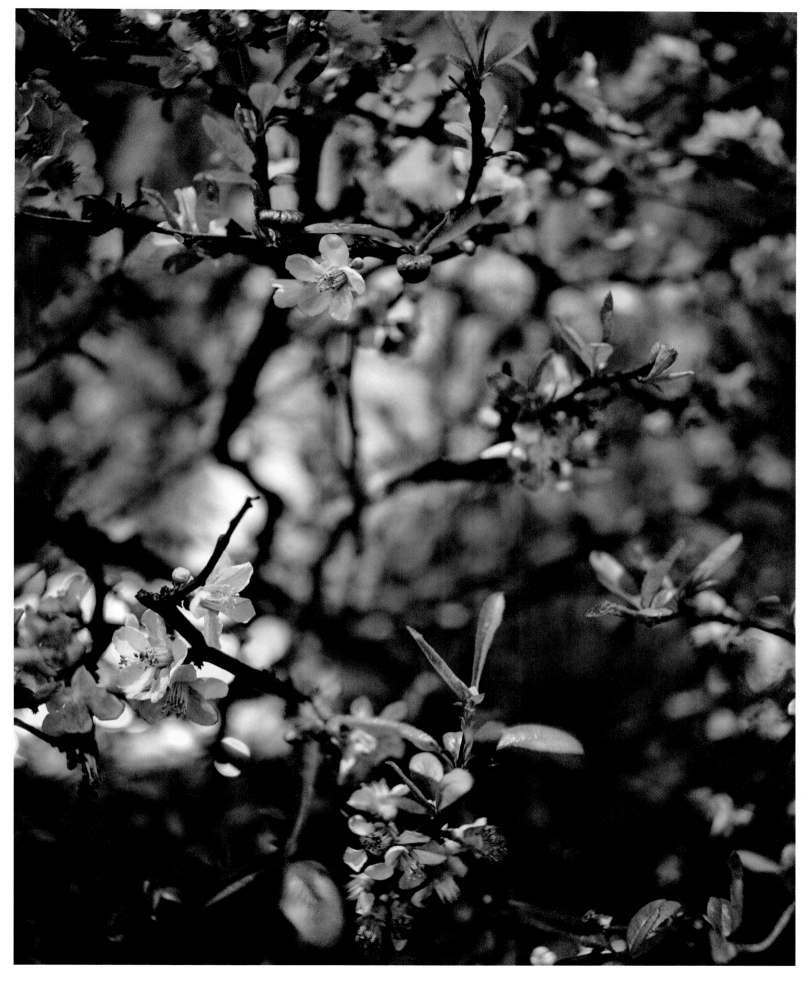

Untitled, 2002

It's alright, Ma (I'm only bleeding) Simon Pooley

The first image he told me about was a Polaroid of a sick and frightened looking young man, taken in St. Annes-on-Sea, Lancashire, in February 1996. He said that this rude portrait of him was taken by a nurse, whose name and face he could not remember, on the morning of his arrival at Pierpoint House Rehabilitation Clinic. He told me that the photograph was unusual in that it was taken quickly and without warning; that he was not allowed any time to adjust himself for the camera; that it was a surprise conclusion to an otherwise routine medical examination; and that he saw the image only once, briefly, before it was filed and locked away and then lost forever. He said that in the years that followed he had become marked by this one particular image, that somehow he knew that it captured the experience of addiction for him, but how or why he'd never been able to fully comprehend. He told me that he was now certain that he'd finally arrived at the answer.

He wrote me: I disappeared in January 1996. My mother made the phone call to report me as a Missing Person and the authorities asked her my NAME? AGE? HEIGHT? BUILD? HAIR COLOUR? HAIR LENGTH? EYE COLOUR? COMPLEXION? Then: COAT? UNIFORM (OUTER)? UNIFORM (INNER)? UNIFORM (LOWER)? FEET? OTHER? And so on and so forth. One further category was negotiated: FREE TEXT – it must have read something like this: *He was last seen at home on the morning of 10 January; at some point during the day he left the house. A few items of his clothing, his wallet and his passport were missing. He failed to return. Chaotic drug user; prescribed methadone; potential suicide risk.* The information was logged, data-based, processed and a message relayed to my mother: NO TRACE. And that was that: Missing Person; Potential Suicide Risk; No Trace.

He wrote: The Free Text was almost right, just substitute 'Potential' with 'Definite'. Have you ever wondered about the genealogy of a suicide? Mine started with nothing more than a rogue thought – a rogue thought that somehow found its way into the usual psychic trajectory I accelerated into on what had become an otherwise normal morning: I awoke with junk sickness, thought 'solution?'– schemed a scheme or two to get some, felt slightly better, remembered that this was truly hell, felt slightly worse, thought 'solution?': 'Doctor'; 'Relocate'; 'Therapy'; 'Hobby'; 'Detox'; 'Sport'; 'Anti-depressants'; 'Job' – the usual stale litany of suggested and discredited remedies – and then, out of nowhere, 'Kill Yourself'.

He wrote me: I contemplated this kill yourself option and reasoned it to be a simple and fool-proof, one-hundred-per-cent-success-rate antidote for heroin addiction; upon further reasoning I then dismissed it on account of the possible pain I might have to endure and because, in the absence of any coherent religious or metaphysical beliefs, I was terrified of death. While the pain I was in was certainly acute, I concluded that a suicide attempt would certainly entail a superior form of agony – eternal damnation, even. As time progressed and my condition worsened my view on this economy of suffering reversed itself. I fantasised a suicide with increasing frequency, projected my hopes and dreams onto it in the same way that others cling to the happy promise of a retirement on the Costa del Sol. I thought about it in greater and greater detail: How? Where? When? There were infinite variations, so many possibilities. I could not make up my mind, I didn't want to commit, but surely could go on no further? And then, on a January morning in 1996, I decided to do it and I disappeared.

He wrote: The final request made of my mother by the authorities was to provide them with a photograph of the missing person: a recent photograph, one with a good likeness. She looked but there simply weren't any. An exhaustive search revealed that I faded into photographic obscurity circa 1992; the last picture she could find of me was taken on my eighteenth birthday – after that, nothing.

He told me: It was here in the family album, in these private snapshots, that the story of my addiction was told and where my disappearance was most tellingly delineated. Up until the age of about eleven I'm consistently represented, staring out from almost every page: a generic newborn cradled by an uncertain looking mother(1973); a fat-faced toddler sat on Santa's lap, trousers tucked in wellies (1976); my first day at primary school (1980); my First Holy Communion (1983);

my first day at big school (1985); on family holidays (Anglesey 1979, Torremolinos 1982, Rimini 1985, Tenerife 1987, Orlando 1988); at weddings, at baptisms, and so on – the usual variation on a big occasion that families feel fit to solemnise for their own special pleasure.

He wrote: And then my presence begins to dissolve. I appear occasionally between the ages of eleven and eighteen, but only with an accumulating sense of awkwardness and reluctance. There are no single portraits; instead I take my place at the edge of the group, in the background somewhere – out of the way, out of focus, out of sight. I begin to look increasingly withdrawn, fragile and anaemic, as if my health and well-being were somehow dependent on my being photographed. The image taken of me on my eighteenth birthday shows me in the final stages of this photographic anorexia: I'm stood posed in front of the new car that my parents had bought me and I look as if I'm about to collapse. And that's it – after this image my presence could no longer be verified.

He told me: It's no coincidence that my image wanes from eleven onwards – this was the age at which I first began to investigate what, at this point, seemed to be the potent delights of the stuff kept in the cupboard under the sink: glue, gas, polish, thinner, lighter fluid, air freshener. My research continued throughout my mid-teens, increasing in its ambition and intensity, becoming more refined and sophisticated in its subject matter: Dope, Acid, Speed, Mushrooms, Ecstasy, Benzo's. By eighteen I was completely fucked: skag-addled, needle-fixated and methadone 'scripted'. I tried to quit, I failed; I tried again, I failed again – for nearly two years, always trying and always failing and then concluding: *I am weak, I have crossed a line and there's no going back now, this is it.* Given no option, I unconditionally surrendered to addiction – it swallowed me up and the photos stop.

He wrote: When I think of these images, when I consider them in order, the narrative I see being played out is not that of the passing of time, nor of the folly of time, but rather the narrative of addiction. My protracted erasure from the family photo album signalled my wider withdrawal from the family unit; my wider withdrawal from the family unit signalled my wider slide into addiction.

He told me: Addiction is a lingering extinction – a slow subtraction that, in the course of its full orbit, dissolves, corrodes, leaves you with nothing and then finally nothing. The family album reveals this evanescence perfectly through its chronicling of my documented body, but an important lacuna still persists: the succeeding three years, from eighteen to twenty-one – the period in which my addiction reached its denouement; the period in which the physical body disappeared.

He wrote: There are no images to account for these years but scars and wounds and physical aberrations remain and lend themselves to memory like so many old photographs.

He told me: The body tries to resist and mends itself quick, but the perpetual insults that a determined addict visits upon the flesh are quicker. It cannot compete, it gets confused, it retreats. Veins refuse you entry, become as hard as glass; where once they offered a probing hypodermic a welcoming gush of deepest crimson, they now emit nothing but a miserly trickle of scarlet – the vein is dead: avoid. So you look elsewhere and plunder and berserk your body until there's nowhere left, but you still keep trying.

He told me: To use intravenously is to enter into a sub-culture within a sub-culture – a schismatic territory shunned and derided by the sniffers and snorters, the pill-poppers and puffers, the chasers and the casual dabblers. This is narcotic fundamentalism and the stakes are raised and the body-count increases and its intensity scares them.

He wrote: I never thought that I'd go this far, nobody ever does. And even when you've finally got that needle in your arm there's always someplace worse that you could be sticking it and you think to yourself: 'Well, at least I'm not *that* bad!' Even with IV use a certain form of stratification still exists, a snobbery that separates the better-offs from the worse-offs, the fucked-up from the completely fucked-up. It elevates those who fix in their hands and arms above those who fix in their legs and feet; those who fix in their legs and feet above those who fix in their groins and, finally, those who fix in their groins above those who fix in

their necks. The body is carved up into a series of upmarket, downmarket and somewhere-in-between zones; your track marks become not just a signifier of addiction but, according to where they are, also of your addict caste and status – of how you're fairing in the game. In my own spiral of downward mobility I mined and exhausted my arms, my hands, my feet, my legs, and my groin. All my veins had vanished, my body had evaporated and I hobbled about because my feet were bloated with abscesses. I would be dead soon, my gravestone epitaph would read: 'He never fixed in his neck'.

He wrote: The suicide attempt failed. I didn't bungle it or change my mind and it wasn't one of those feigned-attempts-as-cry-for-help stunts. What happened was this: I left home and booked into a non-descript, out of the way, two-star B&B. I went out and bought a sizable quantity of Heroin, a chunk of Hash, some porn, a tracksuit and some trainers – the last tokens of pleasure and comfort that, as a condemned man, I felt tradition-bound to grant myself. I planned to have one final chemical fling and then overdose myself on the last of the Heroin. I was two days into it and boiled as a owl when the hotel management figured out what this hungry ghost in Room 28 was up to and called in the police. I was arrested and searched. They found my passport, radioed my details through and made the connection: MISSING PERSON; POTENTIAL SUICIDE RISK. I was registered at my parent's home so they took me there – from there I went straight to rehab. It all happened so quick. I was on the verge of completing the process of disappearing and the next thing I know: PHOOOM! The flash went on a camera held by a nurse, whose name/face I cannot remember on the morning of my arrival at Pierpoint House Rehabilitation Centre – I reappeared.

He told me that in this Polaroid, or rather in the memory of this image, he now saw himself re-emerge from a state of nothingness into something that was once again verifiable. He said that the answer was there all along – in the rapid materialisation of colour, form and then a person, him, within the framed void of the Polaroid, but that until he linked it with these other images of himself he'd never been able to grasp the relationship between addiction and photography. He told me that when people ask him about his addiction, about his disappearance, he still finds it hard to articulate what happened, or to order it or to explain it; all he can do is to tell them about the images. He told me that for some people photographs speak of death and loss and he understood this, but for him they could now only ever speak tenderly of life. Finally, he told me of other images that he has since added to this narrative, the ones taken since 1996, the ones that he says both confirm and consolidate his existence and the ones that tell a much different story than that of addiction and disappearance but which will, for him, forever echo it: in his hat and gown on his graduation day; with his father at his fiftieth birthday party; eating Sauerkraut with friends at a German restaurant somewhere in Spain – Marbella, he thinks, or possibly Fuengirola?

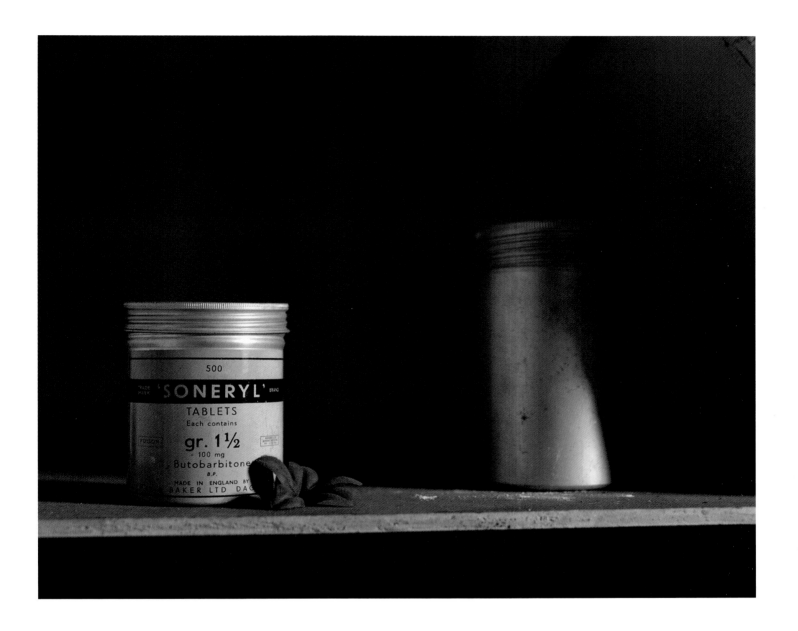

The Undertakers: Untitled, 1998

Ibiza

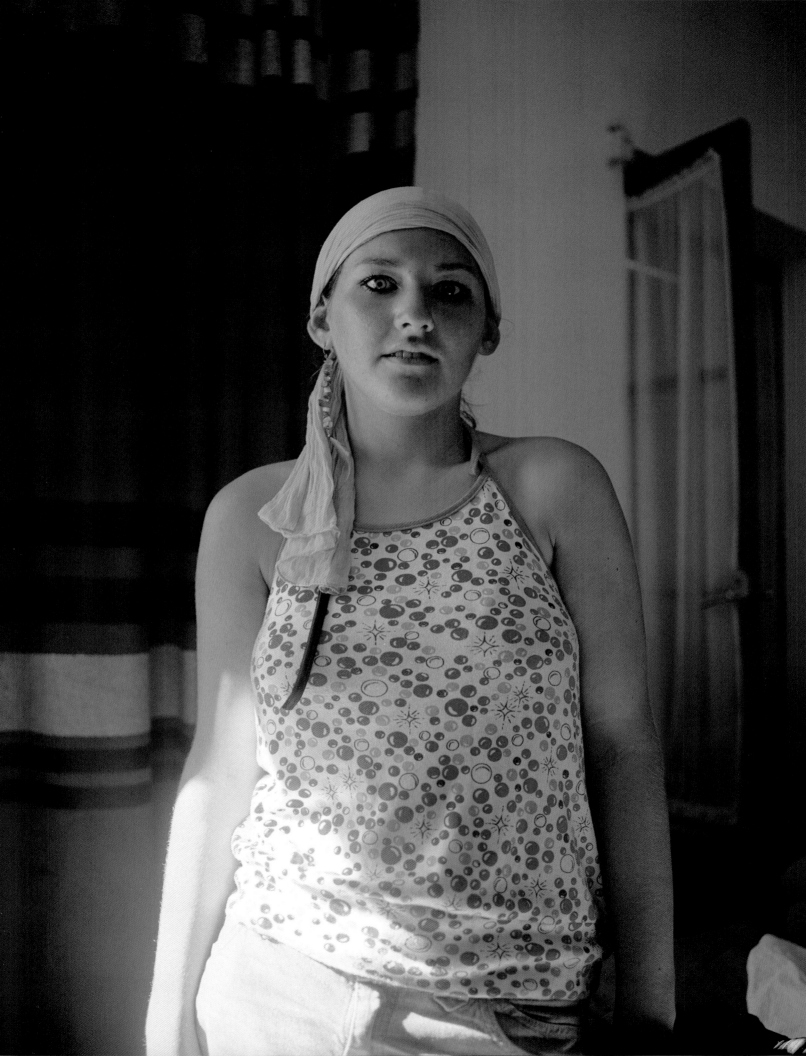

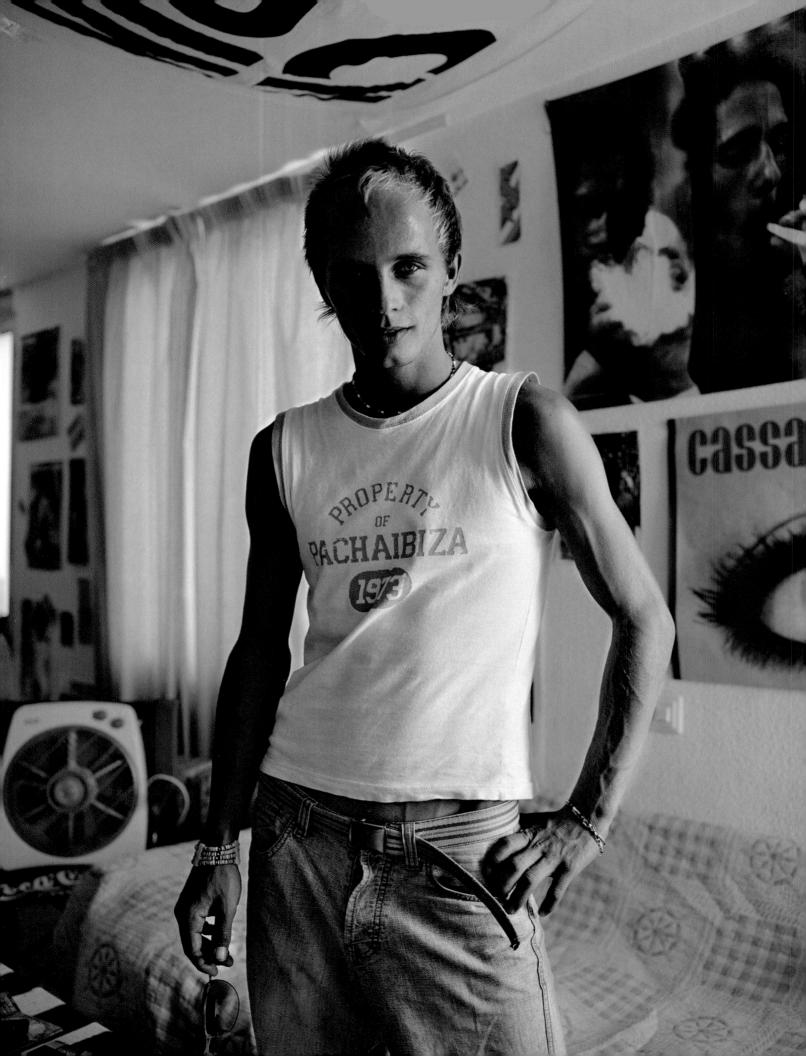

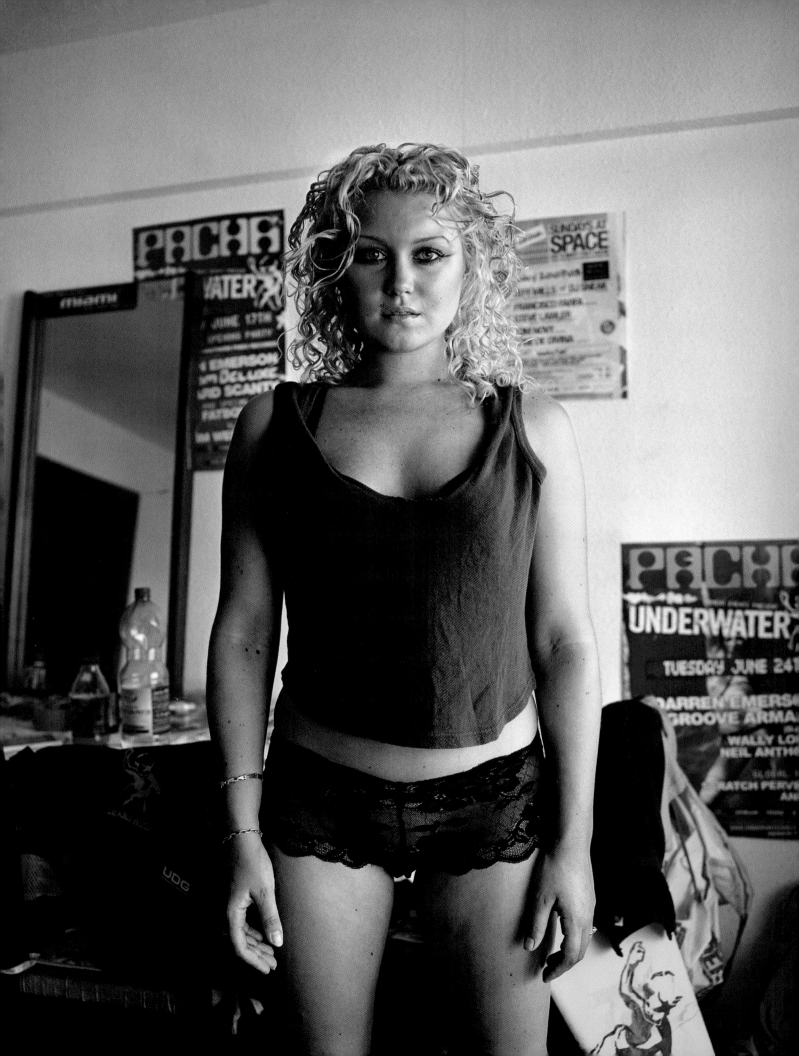

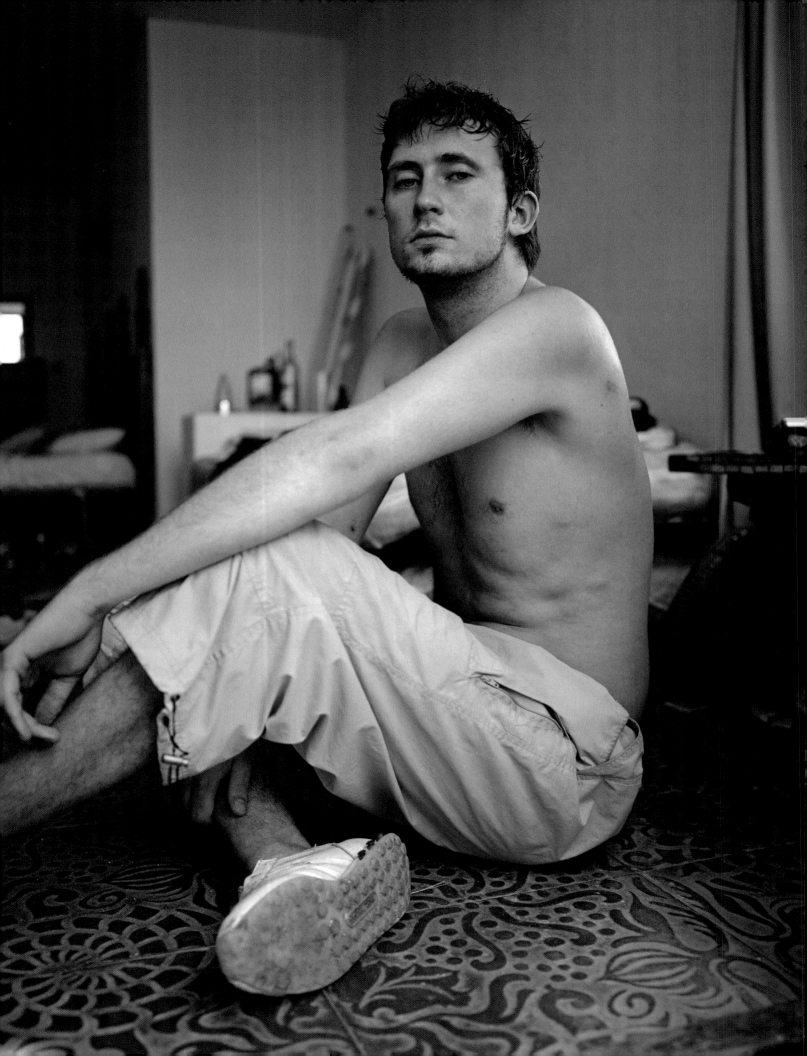

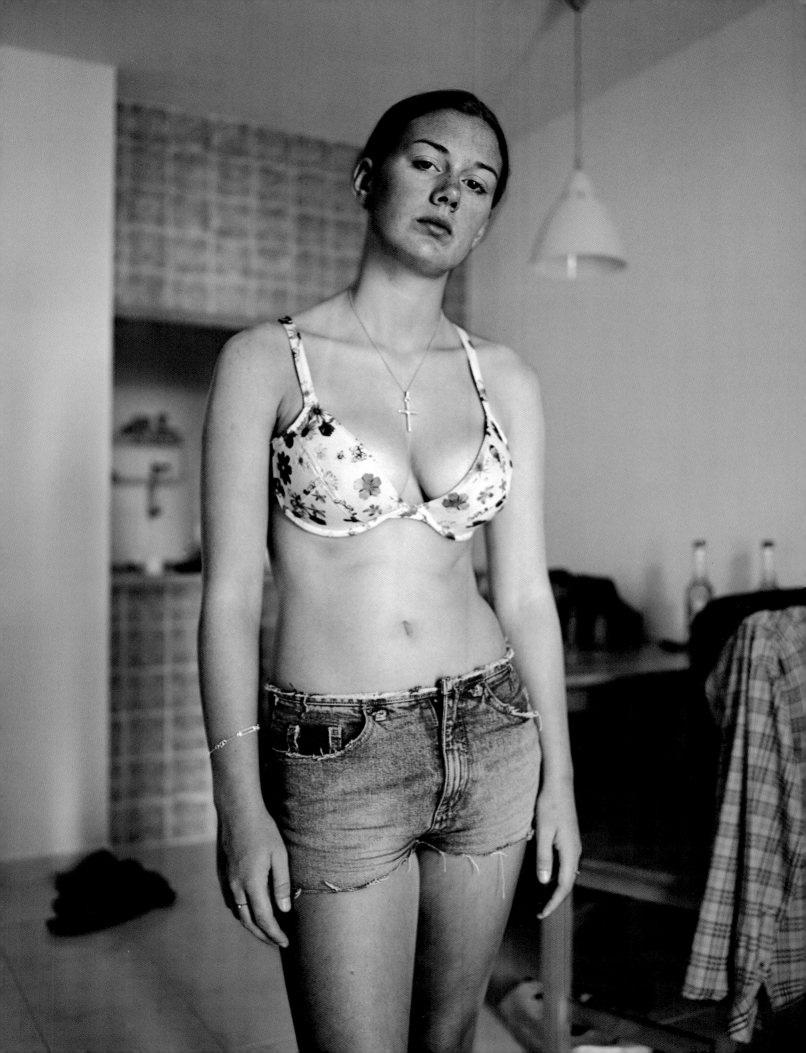

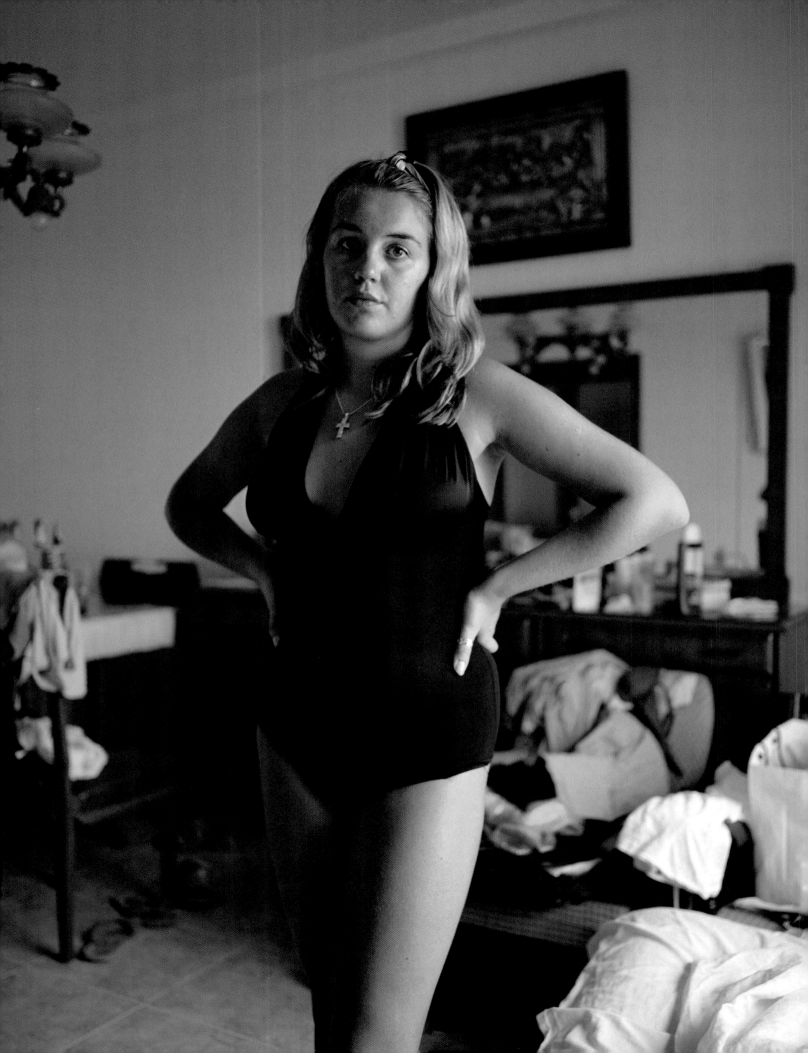

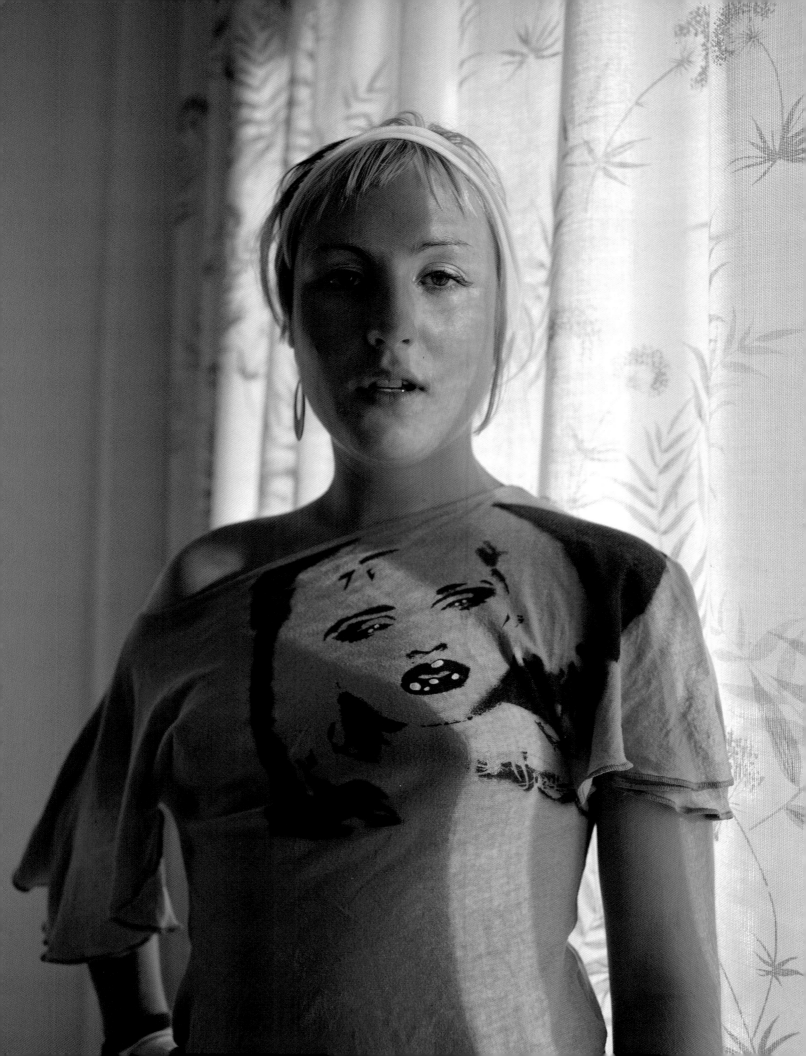

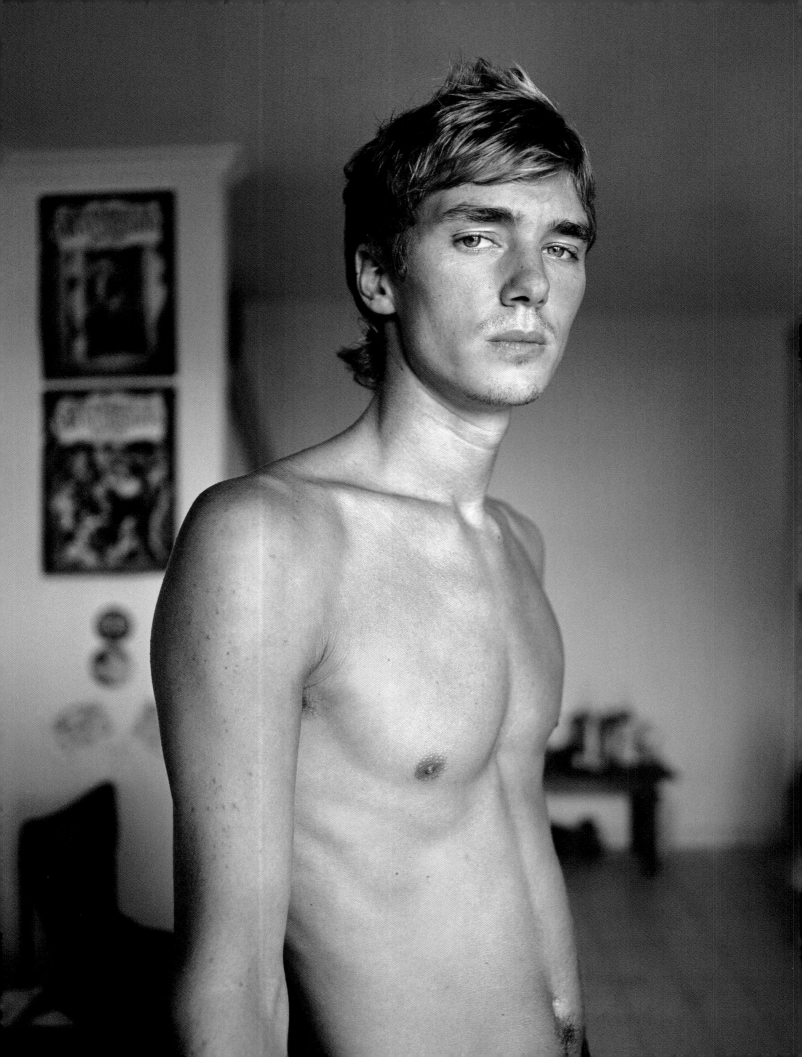

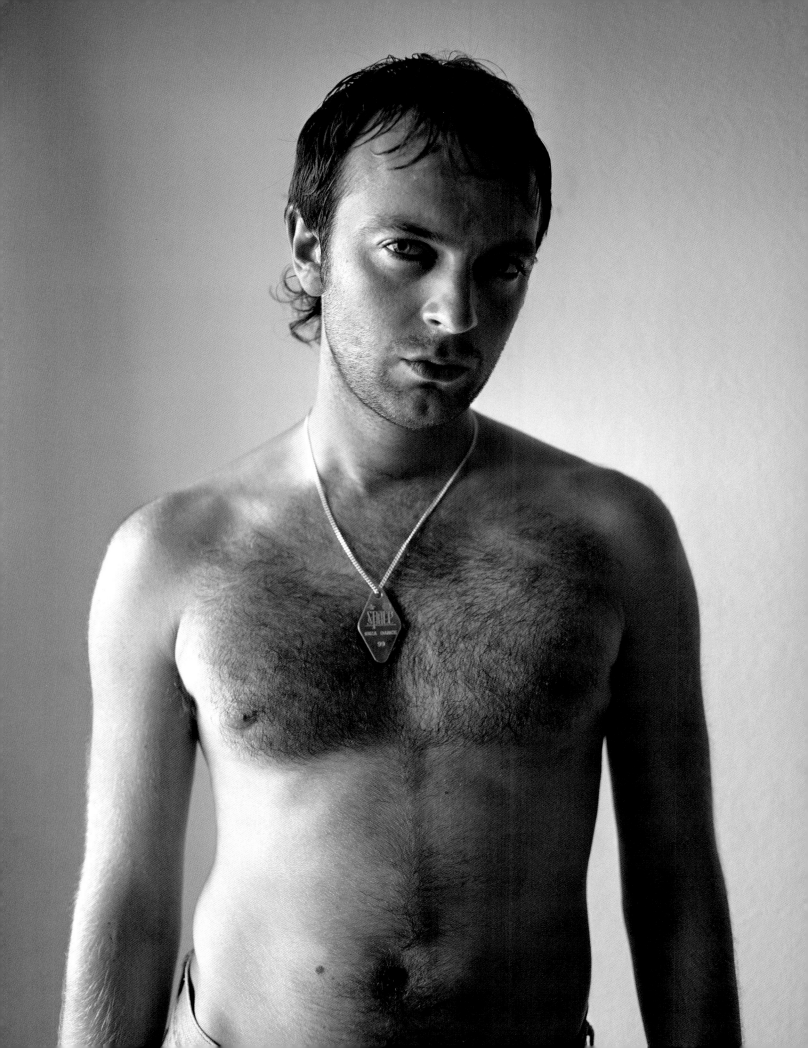

The Undertakers

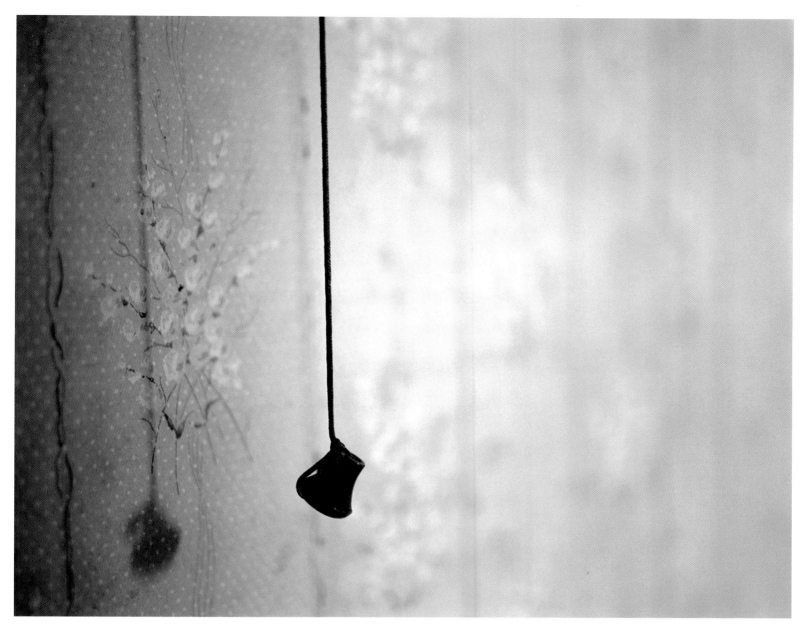

Untitled, 1998

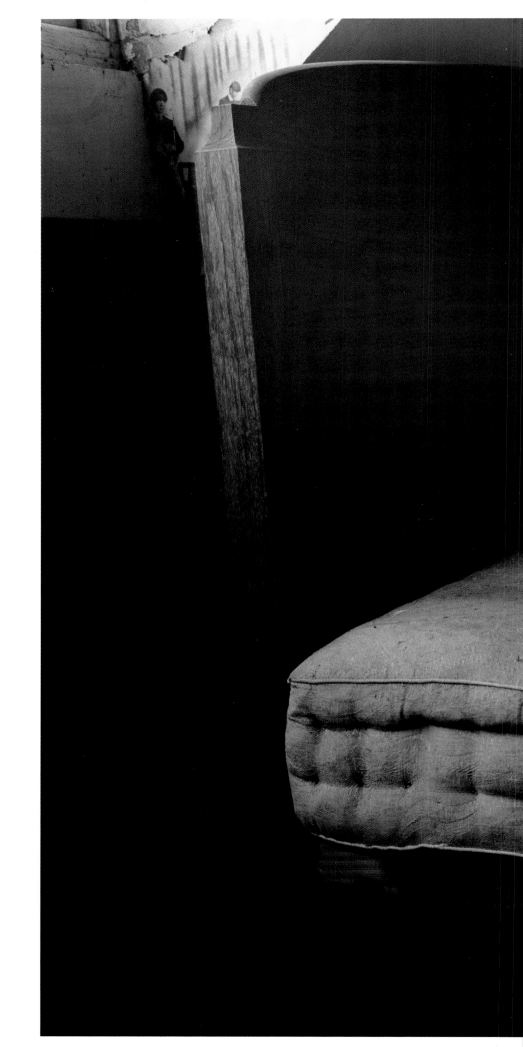

Untitled, 1998

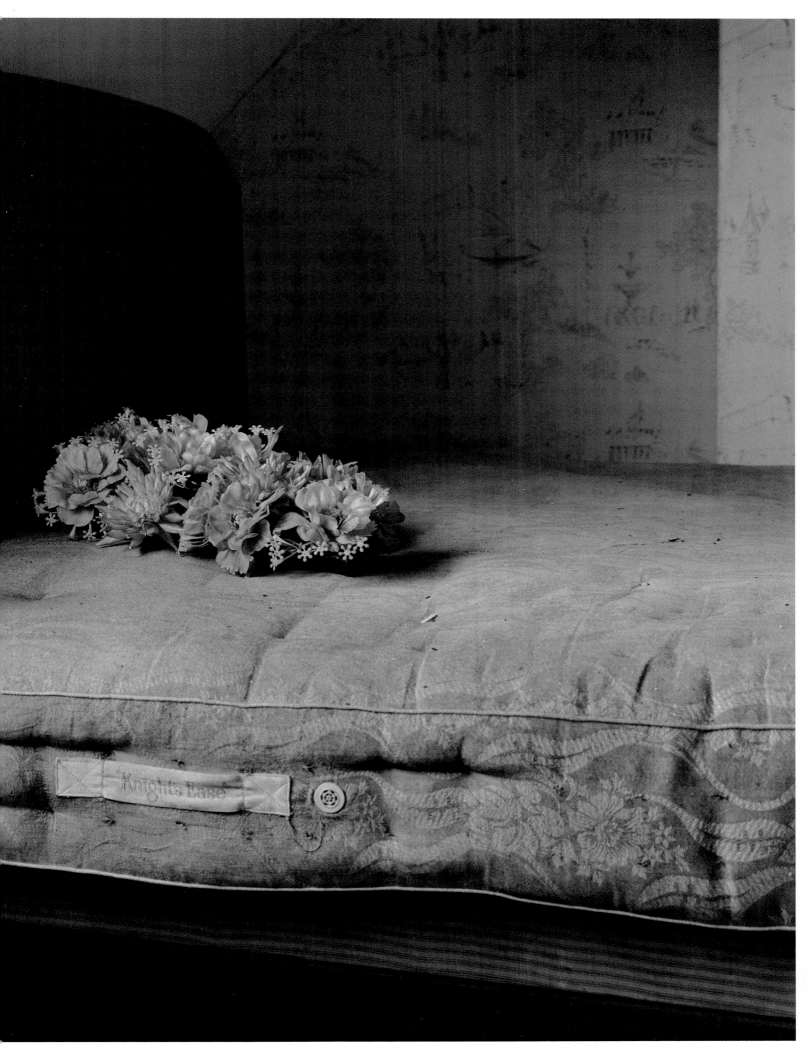

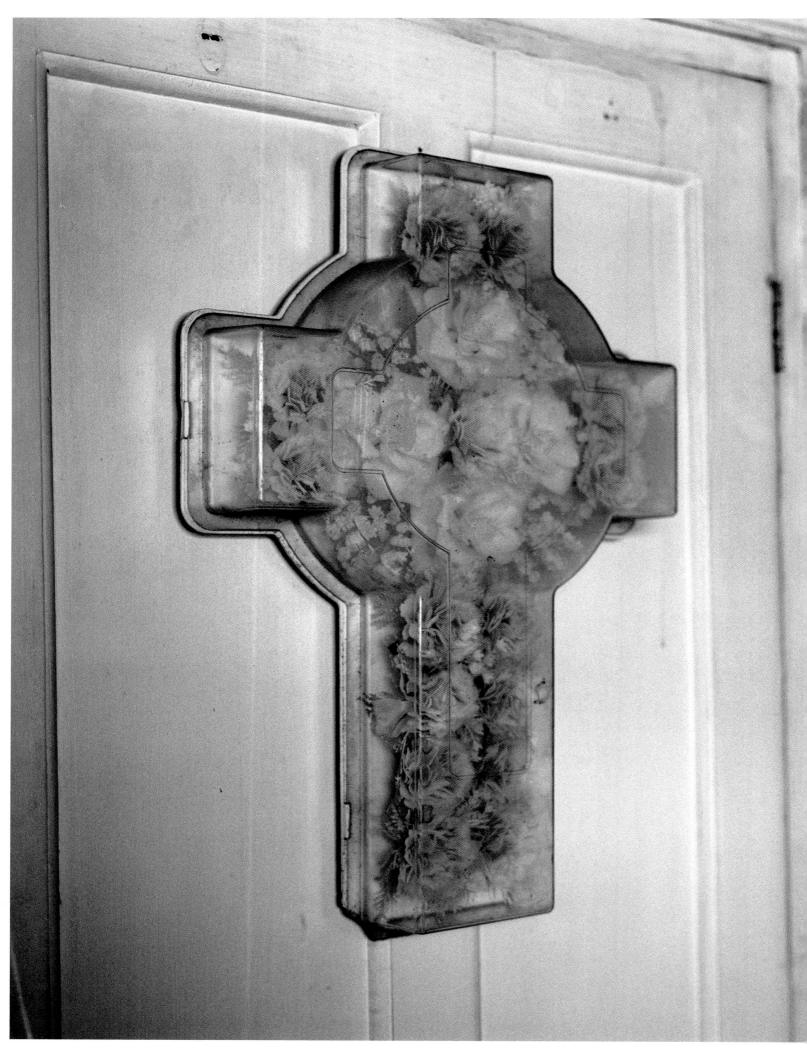

Untitled, 1998

Details of Sectarian Murals

Untitled, 2003

Untitled, 2002

Untitled, 2002

Untitled, 2001

Untitled, 1998

Untitled, 1998

Interview Gareth McConnell and Charlotte Cotton

Charlotte Cotton The earliest of your photographs in this book date from 1995. What is the significance of this as the starting point of what you wanted to show here?

Gareth McConnell The book begins with a series of work called *Antisocial Behaviour (Parts I and II)*. The first part shows the physical scars on men's bodies from punishment beatings in Northern Ireland, so inflicted wounds, and the second part shows the self-inflicted wounds of IV drug use. I was studying for a BA in photography at the West Surrey College of Art and Design at the time and the punishment beating photographs, I think, reflect the fact that when I moved to England I saw my homeland as an immediate source of material for my work. I think it was the time for me to try to comment politically. I later came to realise that I wasn't in a position to do that well, because I had more than a degree of ignorance about the subject and that my work is more about trying to make sense of my position and identity, even when dealing with a politicised subject. I can see how much I have changed since I made this work and I am uncomfortable with it because I was especially uncomfortable with myself at that time. All the same I feel it still stands as the beginnings of me communicating through photography.

CC When you look at your photographs do you see them as a diary, a record of your states of mind?

GM To an extent. The difference between the punishment beatings in Part I and the self-inflicted wounds of Part II, is that I have no direct experience of punishment beatings. Violence has played some role in my life, but drug use was very much part of it. I knew the people in Part II personally, whereas I had to find the men shown in Part I. At that time, I was still very much captivated by the fantasy and romance of drug culture. There were many things that I was looking for and felt that I had found there, such as a perception of autonomy, of omniscience and most prized of all a sense of tranquility and belonging. In my arrogance I never dreamt that what I show in the photographs would eventually become my reality. My experience has since

been that the vast majority of IV users appear to go this way: body, mind and spirit decimated in the pursuit of pleasure, even when that pleasure becomes rooted solely in the relief of pain. This work is important to include here because I had a very positive critical response to it, it engaged people and I don't honestly know if I would have carried on taking photographs if it wasn't for the support that I was given at this stage.

CC From West Surrey College of Art and Design, you went on to study for an MA in photography at the RCA, London, in 1997-9. What work did you make during this time?

GM There are a number of series in this book that I made while I was at the Royal College, but the only one I made in England was the *Survivors* series. There's no reason to go through the individual stories of these men, but each of them were associates of mine who were just existing, as opposed to living, at the time I photographed them. Most of the work I made during that period was done in Northern Ireland. My time in London was really about getting and using drugs, but then I would go home to Ulster to produce work and during these periods I would simultaneously slow it down to a maintenance level. The way I look at this now is that these were the times when I opened up, and that even for just a week, or two weeks at a time, I came alive again. It gave me a real sensitivity, as if I could very clearly see things. When I look at these photographs they startle me because they were the moments when the outside world really touched me and I was able to engage with it. My consciousness had been raised sufficiently for me to be able to photograph.

CC Another series made at this time was the Albert Bar photographs. What was so special about this place? Why did you want to photograph there?

GM This is a Loyalist bar in my hometown. The Good Friday Agreement was coming into effect when the photographs were taken, in Spring 1999, and the paroling of political prisoners had begun. For the patrons of the bar these events undoubtedly held

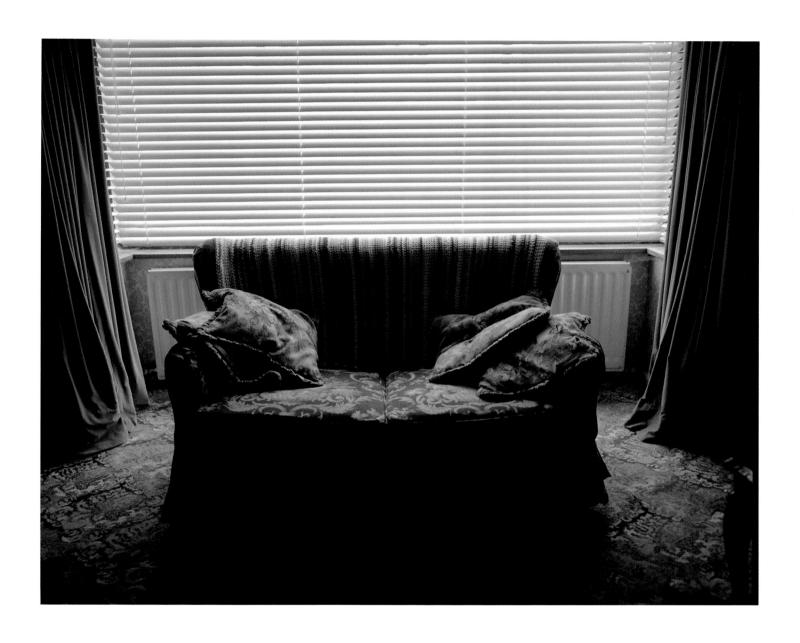

My Grandfather's House: Untitled, 2002

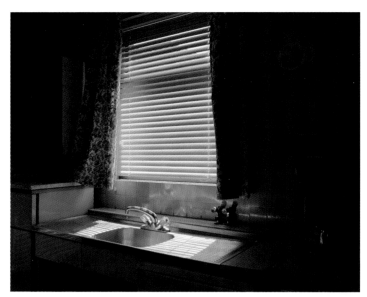

My Grandfather's House: Untitled, 2002

an immediate significance to their lives while I found that my own relationship was more ambiguous, more distanced. This raised questions for me about the nature of cultural identity and indeed my own lack of it. So, on the one hand it was about photographing a very particular historical and political moment and, on the other, about me trying to figure out my own status within it.

CC Is that also true of the series on abstractions of political murals in Belfast you were also working on at this time? They feel like very sensory experiences, and I wonder what, in retrospect you think this work was about for you?

GM I've been photographing them for over five years now, and while a lot has changed for me over this period, including my relationship to Northern Ireland, my basic motivation for photographing the murals in this way remains the same: this

has been an attempt to go beyond their political rhetoric in search of something more absolute, more aesthetic, more peaceful even. For all the violence and separation and injustice the murals can refer to, the causes that they serve are ultimately about hope and betterment – and what is there without hope after all? Through politics and religion there is always a utopian aspiration towards peace, freedom and serenity, but things seem to get messy and confused – the murals being a perfect example of these distortions.

CC There's another element of your work here from this time that concentrates on the interior of one uninhabited building, *The Undertakers.*

GM What initially attracted me was a sense of peacefulness and clarity, something I had also found in the Albert Bar. I didn't look back at these photographs for over a year after I had taken them. It was a moment when imagination and abstract thought didn't get in the way of a more clear and distinct intuition.

CC I sense that there are two main ways that you work. There are those series where you have consciously developed an idea that holds the subjects closely to a particular place or state of mind. And then there are also those bodies of work that are, I suppose, the 'Nirvanas' of photography, made quickly, by-passing your conscious mind, where the meaning of the work comes later, after the photograph has been taken.

GM It's certainly the case with the *The First Man To Remember My Name*, which must have been made in less than half an hour. It was only sometime later that I realised that every photograph we made that day gave something and needed to be seen together like they are here. An example of another approach – of working on a tightly controlled series would be *Institutions,* which I have been shooting since 2001. Here I very much knew what I wanted and set about casting and photographing. There is nothing spontaneous in the concept of this work. I would explain to the person concerned what I was doing and make an

arrangement to meet. From that point, we would work closely together using the space and light available to arrive at the final image. This could involve long periods of time and minute adjustments in regard to light, position and framing. The success relies in the total co-operation of the sitter. Some of the people here I have photographed time and time again and no doubt will continue to do so. With either way of working, looking at the contact sheets is always a mixture of surprise and disappointment. I don't think you ever really know, no matter how you are working, what is there in the print until you see it. Often, I live with the work for a while and allow the pictures to grow on me so that an idea of how to develop a series or approach can accumulate.

CC I haven't seen the photographs in the *Boxers* series before now. I sense that these are not professional boxers, but men who aspire to some sort of strength and identity that comes out of physical training.

GM That's absolutely right, none of the men represented here are boxers as such, so the title refers more to the dream or aspiration than to reality. The setting is a makeshift boxing gym above a bar in Bournemouth. The men in the photographs are from all over Europe and for whatever reasons have come to live in the area. I was training in the gym myself so I felt we had shared reasons for being there, perhaps of defining masculinity, for the purpose of security or self-esteem. Personally speaking, I wanted to get tough on the outside because I felt so tender and raw internally, a physical solution to a spiritual condition.

CC From this work onwards, there's a very definite sense of a style and approach emerging, a preferred way of staging a portrait using available light and 6x7 medium format camera.

GM Around the time of this work, I was awarded a commission to photograph the residents of Quay Foyer in Poole who are sixteen to twenty-five year olds living in subsidised housing. This was my first major project after an eighteen-month period

of not even owning a camera. I think this is where I find the rhythm again, and that's also apparent in the portraits I have made of young people in Ibiza.

CC Many of your portraits are of people you know, friends and acquaintances – in interior settings or in their rooms or homes – but some of them are of complete strangers. Is there a difference in the way you approach the two?

GM In a way they are the same because often when I am photographing strangers I feel I know them because what I am photographing is my connection to their experience – the things I have been through and the way I have lived my life. With the Ibiza photographs, I had been there in my early twenties and I wanted to go back to see people who were seemingly aspiring to the same things that I had wanted. It was quite cathartic for me, to see that it was both an amazing place and time of life, but that it also had a fragility to it… a fragility that had not been exclusive to me.

CC Looking at all these photographs now, do you feel you have made a very substantial body of work over the last eight years?

GM Some days more than others. A lot of the time it doesn't feel like I have done enough. When I look at this edit I realise how much I've changed. I recognise that these photographs and indeed the process of photography is a means of communication which means a great deal to me and that makes me feel more certain about the conditions or subjects that are going to push me to make work in the future.

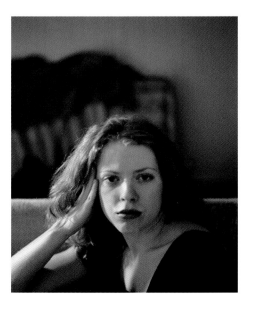

Sophia, 1997

Still lives and Interiors from Mickey Waldorf's

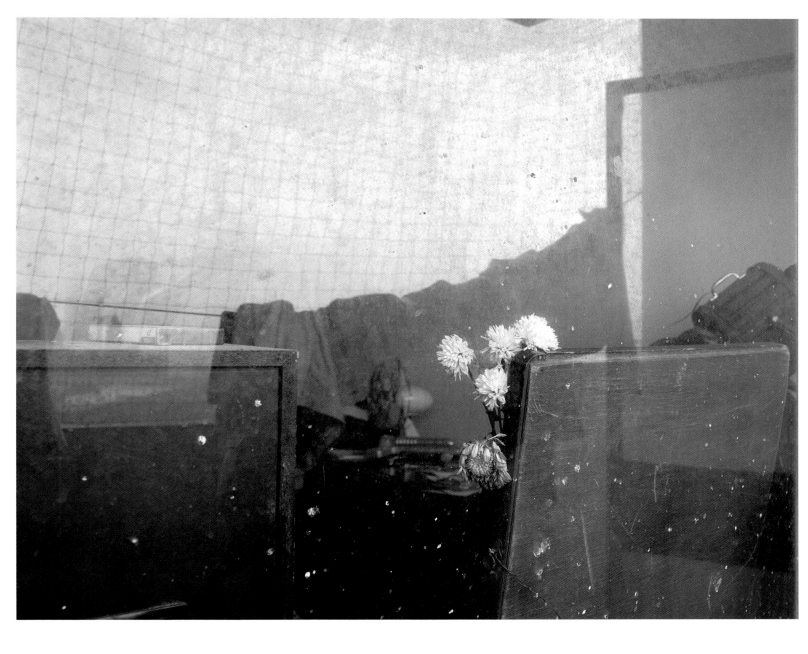

Untitled, 2003

Untitled, 2003

Untitled, 2003

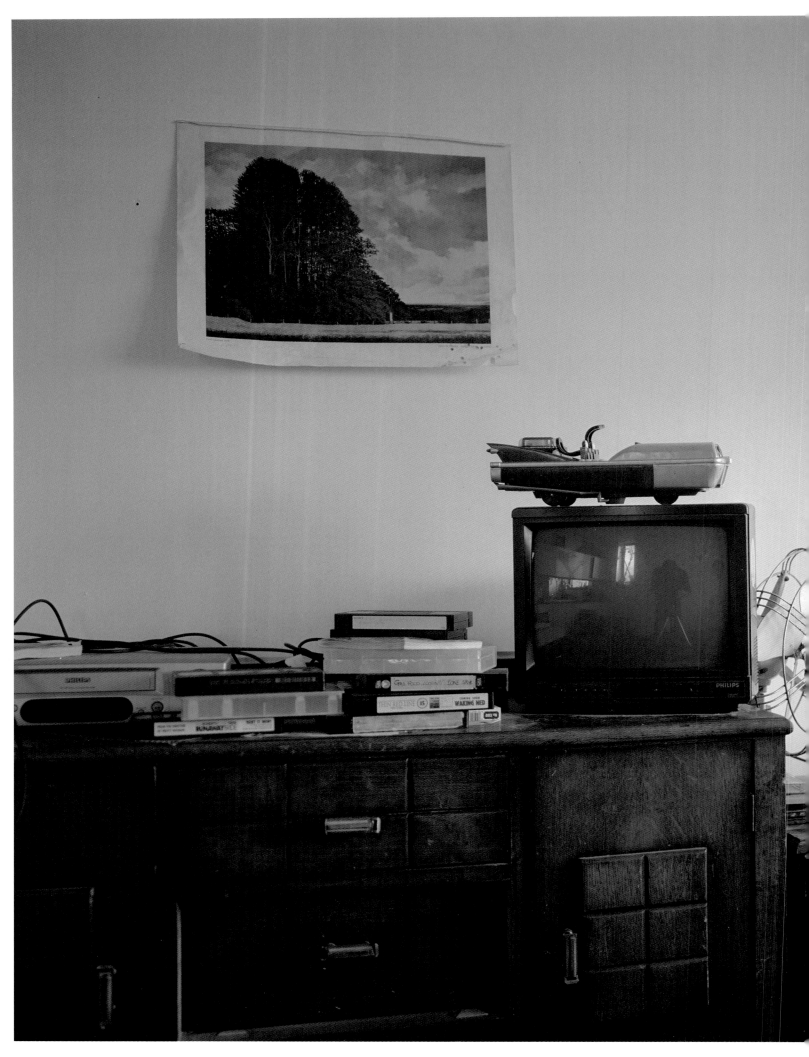

Untitled 2003

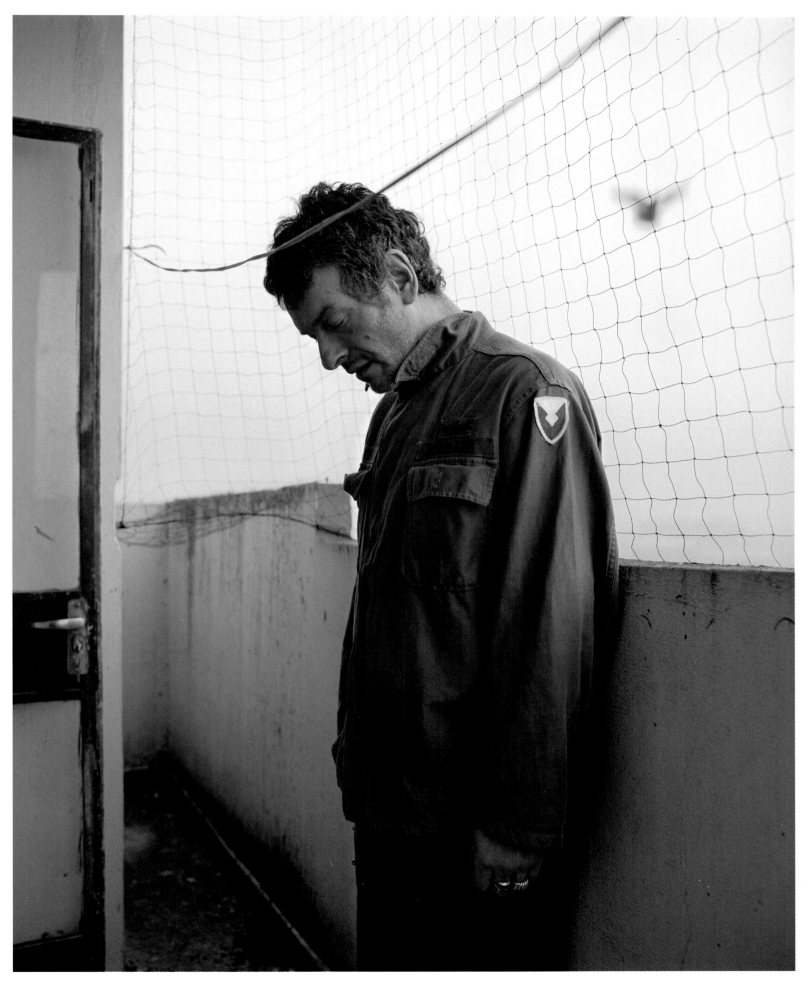

Mickey, 2003

Community Meeting Rooms

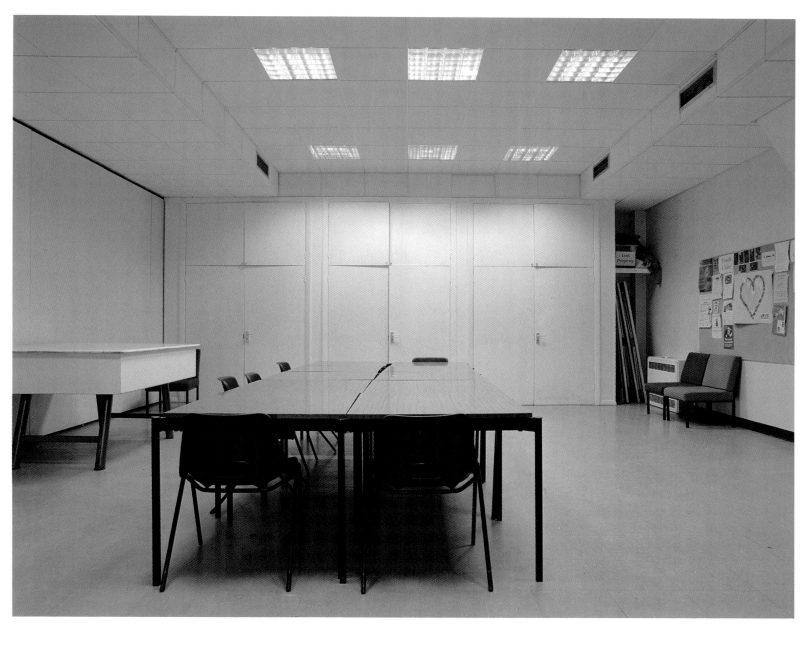

St Peter's Church, London W9, 2004

St Vincent's Community Centre, London sw9, 2004

The Presbytery, London NI, 2004

St Mary's Church, London sw7, 2004

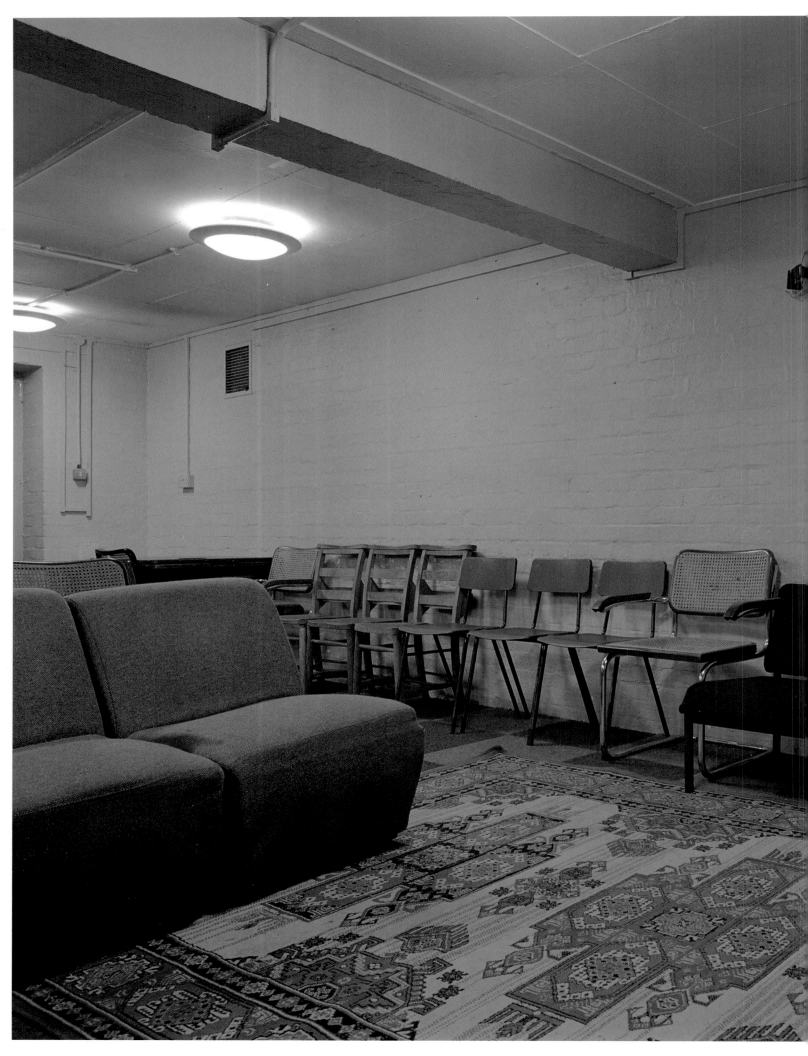

St Helen's Church, London W10, 2004

Grove Community Centre, London w6, 2004

Gareth McConnell
Born 1972 Carrickfergus, Northern Ireland.

Education

1992-96	BA Photography, West Surrey College of Art & Design.
1997-99	MA Photography, Royal College of Art.

Projects and Awards

1998	Source, Olympus Portfolio.
1999	Worshipful Company of Painter-Stainers prize for Photography.
1999	John Kobal Portrait, Runner-up.
2003	BBC Public Arts Programme Commission.
2003-04	London Metropolitan University Residency.
2004-05	University of Wales Visiting Fellow.

Selected Exhibitions

1996	*Antisocial Behaviour Part I*, The First Shoreditch Foto Biennial, London.
1998	*Antisocial Behaviour Part I & II*, Gallery of Photography, Dublin.
1999	*The Show*, RCA, London.
1999	*John Kobal Portrait Award*, National Portrait Gallery, London.
2001	*Wherever You Go*, Quay Foyer, Poole.
2002	*Wherever You Go*, Lighthouse, Poole.
2003	*Details of Sectarian Murals and Portraits and Interiors from the Albert Bar*, Artandphotographs, London. *Institutions*, Unit 2 Gallery, London.
2004	*Back2Back*, Byam Shaw School of Art, London. *Gareth McConnell: Three Projects 1998-2003*, Belfast Exposed Gallery of Contemporary Photography, Belfast.

Publications

2002	*Wherever You Go,* Lighthouse, Poole.
2004	*Back2Back,* All Change, London.

Artist's Acknowledgements

Adam Holden, Alex & Ella Anderson, Alice
Daunt, Andrea Ball, Anna Fox, Archie Elliot,
Barry Gallagher, Beverly Marsland, Bob Austin,
Catherine Lutman, Celia Davies, Charlotte
Cotton, Chris Wilson, Daniel Newburg, Danny
Scott, Dave Lavell, David Chandler, David
Enthovan, David Flatt, Davy Dalton, Dean
Hughes, Dennis Watson, Emma Humphrey,
Gabby Sanderson, Gerhard Steidl, George
Crimble, Georgie Royce, Glen Donohoe, Gordon
MacDonald, Grace Jones, Helen Manis, Hugh
McConnell, Inès Schumann, Ian Bishop, Ivor
Guest, James Whishaw, Janice McLaren, John
Duncan, Julia Braun, Joseph Burrin, Karen
Downey, Katie Grogan, Katie Simmonds, Kelly-
Ann & Christopher Meadows, Ken Grant, Kenny
Lyon, Kevin Healy, Lambeth Social Services, Lee
French, Lee Ramsey, Lisa Stolworthy, Liz Jobey,
London Youth Support, Lorna Guinness, Lucille
Finlay, Lucky Rich, Mark Elliot, Mark Toland,
Mark Johnston, Mark Van Eyck, Martin Parr,
Maya Claughton, Michael Mack, Michael Vogt,
Mickey Littler, Mickey Waldorf, Naomi Attwood,
Neal Brown, Nigel Smith, Patrick McCoy, Patrons
of the Albert Bar, Paul Bruty, Paul Quinn, Paul
Seawright, Peter Baxendale, Peter Kennard,
Philip Mattews, Pretty Pete, Quinton House,
Rachel Rickards, Rebecca Drew, Residents of
Quay Foyer, Roy & Paddy Bailie, Royal College
of Art, Ryan McCormack, Samantha Smith, Sia
Furler, Simon Gofton, Simon Pooley, Sophia
Kennedy, Sophie MacDonald, Steven Morgan,
Stuart Smith, Suky Best, Suzanne Lee, The
Prince's Trust, Thurston House, Tim Macpherson,
Tony Cox, Val Williams, Welsh John, Wickham
Park House, William Macpherson-Daunt, Willie
& Martie McConnell.